Up River

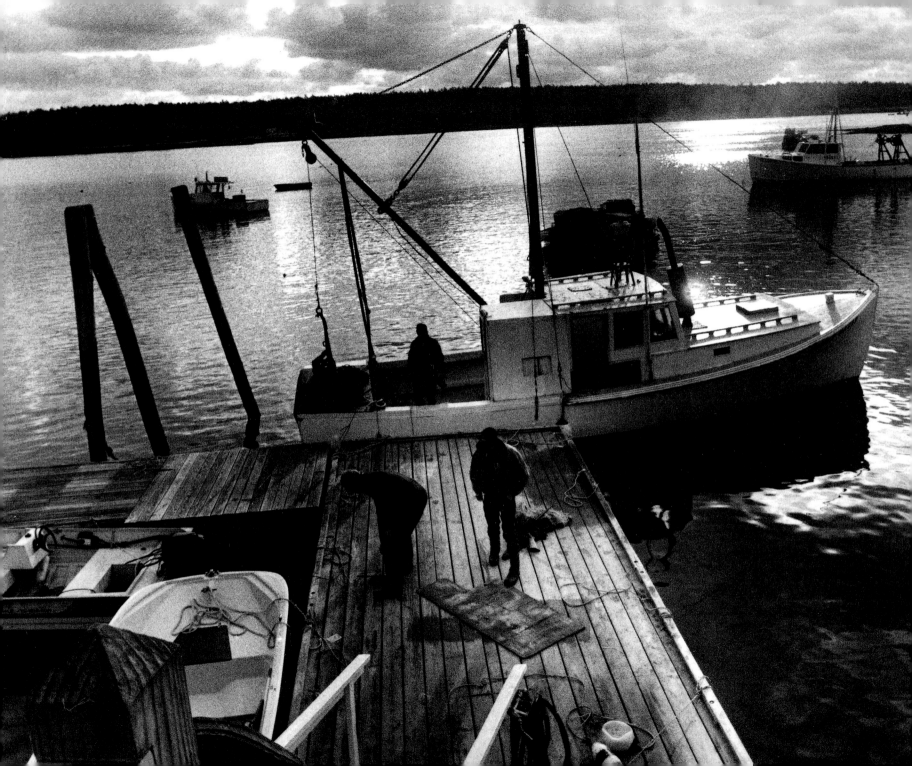

UP RIVER

The Story of a Maine Fishing Community

OLIVE PIERCE

with word pictures by Carolyn Chute

University Press of New England / Hanover & London

University Press of New England, Hanover, NH 03755
Prose text and photographs © 1996 by Olive Pierce
Word pictures on pages ix, 34, 35, 50, 51, 64, 65, 78, 79,
88, 89, 100, 101, 112, and 113 © 1996 by Carolyn Chute

Printed in Singapore 5 4 3 2 1
CIP data appear at the end of the book

Library of New England

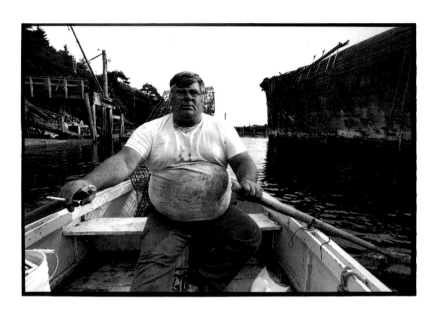

Preface

I grew up in an exclusive suburb of Chicago. Many people were millionaires—steel magnates, meat-packing heirs, railroad executives. My father was a successful banker but not as rich as the friends whose lifestyle he tried to keep up with. The pressure of his ambitions weighed on me and made me wish that I could go to public school like my cousin John whose father had lost his job in the Depression. My cousin's life seemed somehow freer and more adventurous than my own.

I was sent away to boarding school as was the custom in Lake Forest. I went to Virginia. Black people in number and tenant farmers living in shacks on backcountry roads were new to my eyes. I wanted to see more. So, after graduating from Vassar College at the end of World War II, I got a job as the secretary to a United Nations medical team bound for Poland. With my first camera around my neck, I wandered the rubbled ruins of Warsaw and stared dumbfounded at the piles of children's shoes at the death camp at Auschwitz. As I met people and travelled around, my preconceptions about foreigners, about Communists, about Jews went out the window.

Still, it requires constant vigilance to see people as they are. To this day, I sometimes catch myself harboring harsh feelings about the class of people I grew up with, or am unexpectedly smitten with suspicion when I encounter a black person in my neighborhood that I don't know. Even the community in Maine that is the subject of this book may, without warning, appear in a negative guise. But when I refocus my mind and my camera on the particular person and the particular place, the shadows back off.

I am convinced that it is only by reducing the general to the specific that we can make room for change in our own and other people's hearts. The people in the community I have photographed may seem a world apart to someone driving down their stretch of country road. They may even seem from the outward appearance of their lives to be less than other people. My experience tells me otherwise. Their lives have shape and substance; they are committed to work and family; their day-to-day joys and pains are no more nor less than mine. My hope is that after looking at this book the person driving down the road may see beyond the junked cars to the lives that are lived there.

Olive Pierce
Round Pond, Maine

What You Made

(in memory of Freddie and Butch Friend)

Lost limb and ear to his gadgets, winch and gallus,
life to the sea . . .
sauntering walk.
In our time, what became of his free run?
of clever young fathers
who thought what you built, you kept,
that what you lost,
your left leg, your ear, your life!
would be the planted seed . . . for a home forever.
What were they thinking! those girl mothers,
their eager thick-knit immutable nests, building a country?
Twas all along watching
you with its level eyes,
this fit creature that you made to your liking,
made prepossessing,
gave books . . . now pushes you out.
The sea never was the danger,
never was,
though you looked for it there.

Carolyn Chute
Parsonsfield, Maine

Up River

I know the road by heart. I've driven it a thousand times. Sometimes I travel it in my mind as I am dropping off to sleep in my bed back in Cambridge. Turning off Maine Route 32 in Waldoboro, I soon come to a fork and two wooden arrows nailed to a tree. The right-hand arrow—the one that points the way I'm going—says "Neck," but it could as well be a lobster buoy marked "Carter," the name of almost everyone who lives on the Neck except the Harveys who are the Carters' cousins. The road meanders up a stretch of cracked asphalt to the top of a rise where, heralded by trucks and abandoned skiffs and junked cars deep in grass, the community begins.

The bushes straggle, hiding a family cemetery. A farmhouse appears, the homestead of Fern and Carrie Carter, its dooryard[1] adorned with small flowers, a discarded stove, and an unfinished lobster boat on blocks. Fern, long divorced from Carrie, still stops in for coffee, and when there's a boat to build he uses the barn for a shop (page 39), propping up the roof where it sags or extending the space a couple of feet if the hull is too big to fit. Out of this shop have come lobster boats for four of his sons. But his own house is down the road in a hollow. It is pressed into the woods with just enough space around it for his lobster boat, traps in need of mending, his truck, a station wagon that doesn't run, a mess of rope, and a pile of logs waiting to be sold for pulp. Fern and Carrie's children are grown now and have their own families, but there's usually at least one of them visiting—adults in the kitchen, the children outside.

After Fern's house, the road rises sharply out of the hollow and winds on for a quarter mile or so until, announced by a hedge of purple lilacs and a wishing well, the home of Fern's sister Minnie Harvey comes into view. It is not the original house but a replacement for one that burned, and it is now one of five Harvey houses that cluster in a rubbled field—five houses and, in the winter, five lobster boats on blocks and five curls of smoke rising from the chimneys when everyone is at home. There is evidence everywhere of children—toys and bicycles, broken and whole, and a laundry line festooned with small shirts and socks. Wayne Harvey's family (page 86) is the largest. He has eight children, and there were two others: Jeffrey, who died in his crib as an infant, and two-year-old Crystal who drowned in a pool of water in the dooryard where now the other children play and the Harvey horses stray when they escape from the fenced pasture.

1. The open space around the house.

Beyond the Harvey village, the road passes a couple of trailers, Fern's woodlot with the henhouse he intends to remodel and rent, and, a dip or two later, a small pond where the kids skate in winter. At the top of the next rise, a jumble of dwellings appear. They house various members of the family of Fern's brother Burt and include a farmhouse and three trailers and, across the road, a dilapidated boat shop which Burt still uses although he now lives in the next town. Beyond the shop, a rutted road winds down through the woods to Burt's piece of half-tide shore—a cabin in the clearing, a rocky shorefront, and then an arm of Muscongus Bay, or what is known as "the river." The men used to bring their boats upriver to winter them in the clearing, but this practice dwindled as tools and parts were stolen, and now the boats are towed to the dooryards for safekeeping (page 49). Only Burt's own boat wintered on his shore last year. After Burt's shore, the road gentrifies, taking its ease along mowed fields and past a riding stable where children in jodhpurs trot their horses—ending finally in a string of summer cottages on the farthest shore.

Six miles downriver from the Neck by way of a perilously crooked stretch of road lies the harbor where the Carters and the Harveys moor their boats and sell their lobsters. It is called with flat familiarity "the shore" as if it were the only one on Maine's three thousand miles of twisting coastline. The land and wharf and enclosed lobster pound resembling a vast tidal swimming pool belonged first to Bernard "Bunny" Zahn, who ran a successful lobster-wholesaling business until he moved to Florida in 1983, a year after a boat with a Colombian crew

and thirty tons of marijuana was seized at night by federal agents in his harbor. Zahn was arrested but not indicted; several of the local men were indicted, tried, and given prison terms. After that, the business was taken over by Zahn's son-in-law, Loyall Sewall. Both men have figured in Maine politics: Zahn as liquor commissioner; Sewall, a lawyer, as head of the Republican Party. The shadow of the drug bust still hangs over the harbor. So does the hulk of a huge wooden cargo vessel, the *Cora Cressy*. Towed to the harbor from Boston in 1939 after a career as a coal carrier and showboat, she acts as a breakwater and is still an imposing presence as she decays and sprouts small trees and bushes beside the fo'c'sle on her forward deck.

The shore is the heart of the men's lives. The trucks go back and forth from the Neck to the shore as if drawn on a pulley. I learned this one icy November day when, having slid off Route 32 into the ditch, I was waiting for the tow truck to come. It was too stormy for lobstering yet the trucks flew by—first Luke Carter's Toyota, then Norman Carter's green Chevy, then a caravan of Harveys on their way to the shore to check their boats.

Loyall Sewall, who lives in a big white house overlooking the lobster pound, says good-naturedly, "Even at night there's so much activity I can't get to sleep. Raymond Carter was down at eleven o'clock last night to move his boat off the beach onto the mooring."

❋

Fern Carter was the one I knew first. . . . I am the part owner of a hundred-acre wilderness island in the bay

where the fishermen set their traps. Since my now grown-up children were small, we have summered there, making our way to town and back in a fiberglass boat with a fifty-horsepower motor. Eighteen years ago, in 1977, as I was crossing the bay at dusk on my way to the island, I called out to a passing lobster boat, wanting to buy lobsters for dinner. It was Fern on his way upriver after a day of hauling his traps. Idling alongside his boat, I watched him peg the lobsters' claws, his shirtsleeves pushed up above his round forearms.

"Ever been to haul?" he shouted with a voice like a trumpet.

No, I hadn't.

"Then I'll pick you up next time I haul around your island," he said.

And he did. Touched that he'd taken the trouble to come for me, I asked him if he'd like to bring his family onto the island for camping, and he said he would. So began our friendship. After that, he'd come ashore for coffee when he was hauling or leave a gift lobster in the crate tied off our float or call out greetings from his boat, the *Nancy Ruth*.

One day he shouted, "Son Daniel's getting married. Can you come and bring your camera?" It was then that I saw the community on the Neck for the first time.

On July 10, 1987, the day of Daniel's wedding (page 80), the dooryard of Fern and Carrie's farmhouse was dense with people, none of whom I knew. But I found out in short order as Fern introduced me around that most of them were relatives.

"This is my brother Burt," Fern told me, "and Burt's boy Raymond and my sister Minnie Harvey and her boy Neil and my sons Norman and Luke. And that's Uncle Leon come down from Franklin for the day. He was Daddy's cousin. And a lot of these here," he said, using a sweeping gesture, "are my grandchildren."

As if to illustrate, one little girl stopped running and gave him a hug.

"This is Tamya, Luke's oldest," said Fern. "I call her Earthquake on account of she has so much energy."

After Daniel's wedding, I hung around the Neck looking for more pictures. I liked the ruggedness of the land, the richness of the life, the intermingling of people of all ages. The clutter was appealing to a photographer's eye as was the presence everywhere of boats. It was a far cry from the project I'd just finished, pictures of teenagers taken inside a city high school, and I welcomed the light and the space. Everywhere I saw possibilities for photographs, but I started with the children because . . . well, because children never seem to mind. On one of my first rolls of film, I took the picture of Luke Carter's daughters playing in the skiff behind their house—Tamya feeding her doll, Amanda with her arms upstretched (page 41).

Deeper than the surface attractions of the Neck, I felt from the beginning in this intense place a compelling familiarity, almost as if I'd been there before. The tonality was mine—the strong contrasts, the bright highlights, the depth of the blacks. A photographer friend whose work is characterized by silvery tonalities has the theory that there are two kinds of photographers: ones that are attracted to light tones, and others who favor the dark. The first, like himself, "work from the top down"; the second, like me, "work from the bottom up." It's the way we see.

Even though I was a friend of Fern's, I made my way into the community with some hesitancy. Taking pictures of people at close range is a delicate business, and it takes a while to feel out the boundaries. If I asked a fisherman if I could go out with him while he hauled his traps, he might shrug and say indifferently, "I don't care." Yet, if I went, I was offered food and drink and a place to sit if I wanted, and treated as if I were a friend. The first time I went out in a boat for the whole day with Fern's nephew Raymond, I was so worried about having to ask to go to the bathroom that I didn't eat breakfast, but the urge overtook me anyway halfway through the afternoon. "That's okay," said Raymond matter-of-factly, "I'll set you ashore on an island."

One winter morning when I went clam digging with the Harveys (page 58), they started off across the icy flats as if I wasn't there. Do they want me here, I wondered, as I trailed after them with my cameras, or do they wish I'd go away? Irene would know, I thought. I'll ask Irene.

Irene (page 102), thirty-one years old and the mother of a ten-year-old, came to the coast after high school from Mechanic Falls, a mill town in inland Maine. She is unique in being the only fisherwoman in the community, a position she occupies with such dignity that she is universally respected. Relying on her sound judgment, I put the question to her: "Do you think I'm welcome in the community, Irene?"

"Well," she answered with a chuckle, "I expect you'd know by now if they *didn't* want you around."

At first I tried to get the pictures I wanted by running up and down from Cambridge every two weeks or so, staying with a friend in Rockland twenty miles away, but, needing to be nearer, I rented a cottage on the Neck a half mile down the road from the Harveys. Activities on the Neck, as I discovered, are not predictable. It is useless to ask Bimbo Carter on Tuesday what he'll be doing on Thursday because he doesn't know. He may go clamming if the tide is right, or set some traps if it doesn't blow, or work with Raymond on his truck. It all depends on what they call the fair chance.

The law of the fair chance is the guiding principle of the community. If I ask Fern if he's going lobstering tomorrow, he'll pause and say, "Well . . . yes . . . if there's a chance." The broad "a" gives his words extra solemnity. He might almost be saying, yes, if God wills, although his humility is less in the face of God than Nature given the possibility of a gale-force wind or an impenetrable fog.

Or, if there's a god, it's a sea god. In my years on the Maine coast, I have learned a healthy respect for the sea, but there's still that fine line between when it is impossible to go out in a boat and when it is unwise. In drawing the line I might take more of a risk than Fern who has been studying the ocean for a lifetime.

One winter in the space of a month there were three humbling taps from the Almighty Sea God. In January, Fern's son Bimbo, working as a hand on a steel dragger out of South Bristol, was pulled safely out of the Atlantic by the Coast Guard after the boat's boiler exploded, but only after he had been bobbing around in the icy waters for three hours in a heavy, rubber survival suit. A week later,

John and Neil Harvey were returning from clam digging when it started to blow. Their boat sprang a leak, then the motor quit—they grounded out just as the water came over the rail. And before the month was out, Donny Boyington, out scalloping, stepped on a cable and wound his leg into the winch. He backed the winch just in time to save his leg, but six months later he was still limping around his boat with two bad breaks that were slow to heal. "That's a mistake I won't make again," he says wryly.

As I follow the life of the community around the year, I find that I too am governed by the law of the fair chance. Waking one December morning in the cottage I have rented on the Neck, I wonder whether to go scalloping with Fern and his stepson Donny Boyington or photograph Gerald Mank digging a well. I call Fern who tells me that Donny is about to pick him up in his van. They will go to Rockland to get a part for Donny's boat, the *Hippocampus*, take it to the shore to install it, and go scalloping at about 11:00. I arrive at the shore at 10:30 to find the *Hippo* still on the mooring—no sign of Fern or Donny. They were delayed in getting the part, perhaps? Warren Poland would know; he lives nearby. Warren hasn't heard from them, as it turns out, but his wife Betty offers me a piece of blueberry cake, so I sit and talk for a while, then return to the shore about noon. Still no Fern or Donny. After waiting for an hour or so, I give up on Plan A and move to Plan B, photographing Gerald Mank digging the well. But, on my way to do that, I pass the Harveys and a lobster-boat trailer headed for the Neck. The Harveys are taking their boats out and putting them on blocks in the dooryard—I've wanted pictures of that. I

abandon Plan B and follow the Harveys back to the Neck. Plan C, arrived at by the law of the fair chance.

Managing the ups and downs of life on the Neck requires a rainbow of skills. The community runs on the pooled competency of its members. Fern may have a special talent for building boats and his nephew Raymond for fixing motors, but each may be called upon to wire a circuit, lay a foundation, or install a septic system. I admire them the more because I know from personal experience that their skills are hard to learn.

Recently I heard through the grapevine that Raymond had said of me, "She handles a boat pretty good for a lady her age." I was set up for a week. Years ago I was so unnerved by the row of fishermen leaning on the rail watching me come in for a landing in Round Pond, where we had a mooring, that I invariably smacked the boat into the dock. Over the years, as I have come to know the fishermen, the eyes watching from the rail no longer intimidate me. I can land a boat without calamity and have learned to navigate passably with the aid of a chart and a compass even when it's thick-o'-fog. Once, after I had plied my way through a dense fog to meet Fern at the shore, I was disappointed that he made no mention of my seamanship. But reticence of expression is a matter of style in Maine. If Fern had admired my skill, he wouldn't have said so directly.

The community on the Neck functions as one big family. Everyone is close, but the Harveys are inseparable (page 82). On Sundays they gather in the matriarchal kitchen of Minnie Harvey, Fern's sister. The men are shaven and

changed out of work clothes. When they travel, they go in a caravan so that Neil, the family mechanic, can make needed motor repairs. At the shore on their way out to haul, they climb into the Harvey skiff (page 105) which, like a seagoing taxi, drops them off one by one at their boats on the moorings. Breakdowns and delays occur regularly and are borne with patience and good humor.

The Carters used to be as close as the Harveys. What with divorces and Burt moving off the Neck, the ties have loosened a little, but they are still a formidable presence as a family. "They're not as tight as they used to be," Coggie Levensaler, who has known them for years, told me. "but still, if you cross one of them, you cross them all."

People in the community rarely confront each other about small things that annoy them, but when frustration mounts to fury they fight. Daniel Carter, after months of friction with his across-the-road neighbor, lost his temper and broke the man's jaw when he refused to leave Daniel's house. But outbursts like this are infrequent—good will usually prevails. When Raymond's lobster boat was destroyed by fire (page 98), a swarm of friends and relatives dropped everything to help him refit an old boat that had been up on blocks on the Neck. They had him back in the water nine days after the catastrophe. It was assumed that everyone would help, and notice was quietly taken of those who didn't.

It is expected that people on the Neck will carry their own weight—with exceptions. Some can't, like Michael Carter's mother who is ill, so Michael has moved her into his trailer. A few don't even if it seems they could, and these are tolerated and even helped along by the community unless they break some cardinal rule like shacking (stealing from) another man's traps. Minnie Harvey says, "Some people just need to be cared for." It's an attitude she brought with her from Swans Island downeast in Frenchman Bay where she was raised and which she still calls "home" although she hasn't lived there for forty years. The Carters and the Harveys are island people in spirit. The island ethic of interdependence prevails.

Yet I was surprised to find that the umbrella of community generosity extended to me. Fern once spent a whole day at the height of lobstering season repairing the ramp on our island with parts he had brought from his home, and he wouldn't have considered being paid for the work. Since his family picnics and camps on the island, he wants to help with the upkeep. I offered to pay Raymond for putting the ramp and float in the water one spring, but he dismissed me, saying, "Just buy me a six-pack of beer." I'm part of the give-and-take of the community, regarded by the children as a sort of great-aunt who comes and goes, and by the adults as the person who shows up with a camera at family occasions. For Fern, I am both a friend and a worry. Once I was set to drive back to Cambridge in a snowstorm and he didn't want me to go. Being stubborn, I went anyway. Later it occurred to me that I would have shown more respect for Fern if I had stayed. He would have been the one to dig me out if I'd gotten stuck halfway up the road. I am mindful of Fern's thoughtfulness to me on other occasions. One hot July Fourth, I met him at the lobster-boat races in Jonesport, and I wanted to spend a night at the campground there after he had gone home.

He pitched a tent for me overlooking the harbor, fitted me out with a pillow, a sleeping bag, and a roll of toilet paper, and he made sure I knew the location of the nearest freshwater supply and telephone. "Be sure you call if you need to," he said, "and don't forget the fireworks. They start just after dark."

Originally a family of clam diggers, the Carters and Harveys have migrated from place to place over the years in search of work. After the clam flats were closed on Swans Island, they moved on to Vinalhaven in Penobscot Bay, and, when their house there caught fire and burned down, they left for the mainland, settling in Waldoboro in the early fifties. Their intention was to continue to dig clams. But shortly after their arrival, Fern saw someone building a lobster boat and thought: I bet I could do that. And he did.

Soon all the Carters and the Harveys were building boats for lobstering—a development that did not sit well with the established fishermen in Muscongus Bay. Fern often found his traps cut[2] when he went out to haul. So he cut back. When Fern's son Bimbo was old enough to haul, he found one day that all of his traps had been cut but one, and in that one was a knife. Bimbo used the knife to cut a swathe down the bay to New Harbor where he tossed the knife on the counter in the Co-op saying, "Give this back to the guy who owns it 'cause he's going to need it." After that, the Carters were an accepted presence in the bay.

This is not to say that territoriality is no longer an issue. Upriver in the thin finger of ocean that extends from Bunny Zahn's shore to the town of Waldoboro, the battle for fishing grounds rages still. There, one clan squares off against the other to protect its traps. Fern once told me on the telephone that his son Norman was in a fight at the trailer park where he lived with someone who wouldn't tell him which member of a rival family was cutting his traps.

"I think there'll be fireworks here this summer," said Fern, "and we'll all be in it. Lobster wars, we call 'em. What I say is, if we can't fish this river, nobody can."

Even with its clannishness, the community on the Neck has ties to the town and the world beyond. It includes, besides myself, people who are not kin like Arthur Pepe (page 72), the trash collector on the Neck. A local historian of sorts, Arthur is a well-known personality at town meeting though when he speaks the agenda is usually his own.

Community attendance at town meeting varies with the issues. Land-use ordinances dictating lot size, septic system regulations, and the age and condition of trailer homes have a direct impact on people's lives and are hotly contested. The outcome of a vote will decide whether Lionel and Marie Stover will be able to live in the trailer they've just moved onto Burt's land and whether Fern's son Luke will have to put in an indoor bathroom. Generally, the vote splits between the old-timers and the newcomers, and it's often a close call.

Some people in the community are acute and thoughtful observers of the local and national scene. Out clamming, knee-deep in mud, Neil Harvey will put down his fork to discourse on the possibility of urban condominiums turning into urban slums—something that I, living in the

2. A practice of severing the line between the buoy and the trap, so that the buoy floats off and the trap sits useless on the ocean bottom.

city, have not considered. National issues are followed on television. The Carters and the Harveys are Democrats, in the tradition of working-class people, and Jesse Jackson was favored by many of them for the 1988 Democratic nomination. They couldn't warm up to Dukakis. He had already offended them by pushing the seat-belt law which they considered to be a violation of civil rights. Besides, Jesse Jackson seemed more accessible—more like *them*. He shared their cynicism about the system and knew what it felt like to be poor. Neil, who was a delegate to the local Democratic caucus, said of Jesse: "He speaks from the heart."

✳

Sometimes I stop to reflect on this community with my outsider's eye. It's different from Lake Forest, the suburb I grew up in, and from Cambridge, the city I have lived in for much of my life. It's a nineteenth-century model— rural, insular, interdependent. It is male-dominated without question. The portrait of the Carter men (which Fern asked me to take) says so forcefully (page 84). At parties, I notice, the men cluster, talking with easy familiarity about the things that interest them—notably, boats—while the women tend to stand in ones or twos. At the shore, even when the price of lobster is down or the catch discouraging, there is a lot of joking and horseplay among the men. "Boys will be boys," says Becky Harvey as her father Neil and husband Dana steer an erratic course off the dock, wrestling for the helm. The men seem more boyish, more carefree, even with all their cares. Do they have more fun because they are allowed more fun by their women? Per-

haps the women feel, as I have at various times in my life, that fun is an unaffordable luxury.

The boys learn their skills early, usually from their fathers, and practice them often. Eighteen-year-old Shannon Harvey works shoulder-to-shoulder with his father, and nineteen-year-old Sheldon Harvey with his—partners in work and absolutely essential to each other. Ellic, Irene and Fern's young son, has been going out to haul with his mother since he was so small that he slept in the boat in a crate. He's ten now, and he knows a lot about lobstering. Some winters ago, he came to my house in Cambridge for a visit. Stepping in, he looked around and asked, "Where your pot buoys, Olive?" Boys on the Neck spend much more time with their fathers than my brother was able to do, or my son, or my grandsons. A banker or a lawyer can't very well take his son or daughter to the office when he goes to work. It's too bad.

The shore where the men hang out is not a woman's world. Irene is the exception. Accepted and respected by the men, she goes out to haul in a boat she built herself and named for her son, the *Ellic Joshua* (page 111). Other women are a presence only as names on the sterns of boats: the *Nancy Ruth,* the *Nancy C.,* the *Carolyn,* the *Lucille C.,* *Twin Girls.* Karen and Kristine, Wayne Harvey's twin daughters, may go out sterning (helping to bait) when they are young, but it will be their brothers who will get their own boats when they are older.

The women spend most of their time caring for children, keeping house, having coffee with the other mothers just as I did when my children were small. Their lives are bound as mine was to the schedules of the men who bring

home the money. But a lawyer keeps regular hours and a fishermen doesn't; a lawyer usually comes home safe and a fisherman may not. Barbara Harvey always asks Neil what time he expects to be home from clamming so that she can go look for him if he's late. Having to adapt to the whims of tide and weather requires flexibility and does not allow for a lot of personal freedom. But most of the women seem to be comfortable in the traditional role of wife-mother-homemaker. Sheryl Harvey takes pride in each addition to her large family, and the younger children carry the youngest around, fondly, even when the baby has become a toddler and would rather walk. Family and children are clearly the font of joy and hope in this community. As Nancy Carter said, watching a swarm of children romping at a family gathering, "I guess there's no danger of us dying out!"

But perhaps the roles are changing somewhat. It was Minnie, Fern's sister, a woman of my generation, who approved when the wife of a fisherman left him because he was abusive when he drank. "Women don't have to put up with that anymore," she said firmly. While most of the young women still prepare hope chests and marry in white, a few couples live together unwed. Dana Johnson, a fisherman, lives with Annette, the mother of their three children, although their parents would prefer they married. Says Annette of their seventeen-year relationship, "We're together by choice." And Irene and Fern, the parents of Ellic, share amicably in the upbringing of their son though they no longer live together.

Even for the women who do go out into the world, family and community exert a strong pull homeward.

Bimbo's stepdaughter Andrea went off to college but has returned to set up housekeeping with a local fisherman. Burt's daughter Carolyn is struggling to finish college, having broken off an engagement to a man who wanted her to quit. Only Donny Boyington's stepdaughter Tonya, who joined the Army and married an Army dental student from Alabama, has truly moved away from home.

Some of the women take jobs outside the home as a way of supplementing the family income. Some work in seasonal piecework jobs—picking shrimp or sea urchins or packing lobsters and clams. They are not given management positions in these operations even if they are capable of the responsibility. At Benny's Seafood (page 52), a local fish-processing plant owned by a Japanese businessman, the top echelon is entirely male. Recently, when the owner of the sea-urchin company that Irene helped to manage went to Japan for two months, he passed over Irene—the most capable of people, male or female—and hired a man who, Irene said, "could hardly answer the telephone."

Some of the women do work that has no connection with fishing. Shannon Harvey's young wife Jennifer will continue to work at the local supermarket after they are married. Nancy Carter cleans houses; others work in nursing homes. The concept of a career for its own sake is not often thought about. Becky Harvey went to hairdressing academy after high school, but now that she is married and the mother of Michael (page 69), her interest has taken a back seat. "I still love doing hair," she says, "but I don't want to work for anyone else. I want my own shop. I'll have to wait until I have the money." Joyce Boyington, too, would like to have her own shop to sell the wreaths

and bouquets she is skilled at making. With one thing and another, her dream hasn't made it yet to the top of the list.

Many women in the community excel at the making of balsam wreaths. They sell them at Christmastime. Never during the year except for the day when the boats come out of the water in the fall is there such excitement. For once the men serve—and gladly. They help gather brush from the woods (page 54) and boast about the wreathmakers. "Sheryl is the fastest." "Barbara makes them perfect." "Minnie's been at it for forty years." With children coming and going—sometimes helping, sometimes hindering— and with dogs and cats underfoot, the women take boughs and wire and turn out plump wreaths from their balsam-scented kitchens. Until a few years ago, a man in a Cadillac from Massachusetts came and bought the wreaths in the second week of December, paying four dollars for one that would sell for eight in the city. Now the women must find their own markets. After wreathmaking time the Neck returns to normal except that the women now have money for Christmas shopping.

The women on the Neck work in isolation to a large extent, each to her own house. Working in the fish-processing plants is more sociable. At Benny's Seafood, the women sing along to country music or squirt water at each other when they're hosing down the floors at clean-up time. Minnie says life in the community used to be more convivial. There were sewing and canning bees and churchgoing and dances. Now people gather at weddings and funerals and boat launchings. Otherwise, there are VCR movies and television for entertainment.

Minnie, Fern's sister, is the matriarch of the Harvey clan. She is the warm center—the strongest upholder of the family traditions. We are exactly the same age, but she has sixteen grandchildren to my six, and a four-year-old great-grandson. Minnie and Sheldon have been married for forty-nine years. The affection between them is visible. "'Course we have our spats," Minnie explains, "but Sheldon's good. I married a good man." When I, divorced after a twenty-two-year marriage, asked her in some awe how hers had lasted so long, she smiled knowingly and replied, "Because I put in eighty percent of the work."

Children are omnipresent on the Neck, roaming freely inside and out. Cousins and cats and dogs and horses abound. Since there are no baby-sitters except family members and no day-care centers, the children are included in everything. I spent a weekend with the Harveys on Swans Island and marvelled that the kids didn't bicker and fight even though they were sleeping two or three to a bed in a small cabin. Of course the community has its share of family troubles. Some children endure painful personal problems. But there is a sense of shared responsibility— other family members help out. Two young nephews have lived with Nancy and Raymond Carter for years and are as much a part of the family as their own two sons.

The children on the Neck grow up spared the pangs of separation from their parents and with little pressure to compete or excel. These are mixed blessings. My grandchildren may see less of their parents, but the expectations are higher and they have a broader range of opportunities. Who knows what talents are lying fallow in the community? I wonder if Tamya Carter's teachers share my view

that she is an unusually sensitive girl? My apprehension is that she may be seen as just another kid from the Neck who will probably do poorly in school, one for whom there is a predictably limited future. I am sure that Daniel Carter, Fern's son, a gifted natural artist, would have been encouraged to go to art school had he gone to the city high school I taught in. Nancy Taylor, Fern's daughter, says, "There's a lot of talent in our family. With Dan, it's art. But we weren't brought up to dream beyond ourselves. I won't do that to my children. I tell 'em they can be anything they want."

How well do the public schools serve the children on the Neck, I wonder? Many of them are in special classes or are held back or drop out or transfer to the local Christian school in hopes of doing better. Ellic Carter is lukewarm about school even though he has a sophisticated intelligence and knows every species of turtle in North America. And Shannon Harvey, though he was an honor student in high school, found the classes boring.

Why is it that so many of these bright and spirited children are at odds with their schooling? Part of the problem, for those having trouble learning to read, may be the lack of stimulation at home. There are few books or magazines or newspapers lying about. Despite the efforts of the Head Start program to prepare the children for school, they may be already behind when they enter first grade. But, deeper than that, the children stand apart from the mainstream of middle-class society. Ted Ames, a fisherman who has taught school on Mount Desert Island, says, "They are from a different culture, and a lot of teachers don't know what to do with them."

Having been a teacher myself, I have thought about how I would work with them had I the chance. I would start by acknowledging that the children from the Neck *were* from a different culture, and I would give them a chance to demonstrate the skills learned in that culture. It's not every young person who can tend a string of traps or make a balsam wreath or help to build a boat. These are activities that deserve respect. And, having discovered in teaching city teenagers that honoring identity is an almost magical way of freeing a desire to learn, I would encourage them to talk and write about their lives. This rich material could be incorporated into the teaching of language, math, social studies, science, and the arts. My tools would be an openness to a lifestyle different from my own and the belief that each of my students was capable of wonders.

An example of an intelligent and articulate person who failed to thrive in school is Fern Carter. He never learned to read and dropped out when he was thirteen. He thinks it might have been different if teachers hadn't passed him on from grade to grade, regardless, or hadn't told him he was dumb and taunted him with "You just don't *want* to learn to read." Although he was quick with figures, skilled at clam digging, and able to read a blueprint from scratch, he developed a feeling of shame about his inability to read.

"I've done pretty good," he says, "but, still, sometimes I wonder what it would be like to look at a newspaper and know the words." Lately, after turning sixty, he has been thinking he might be ready to tackle the problem.

Reading or no reading, the occupation that the children from the Neck are prepared for is fishing. I some-

times wonder if the industry will be able to absorb all the eager young fishermen that are pushing up in the next generation of Carters and Harveys. Wayne Harvey recognized the possibility of a problem by encouraging his son Sheldon to go to Ohio to train to be a diesel mechanic. "I want Sheldon to have an easier life," he said. When Sheldon came back east, he worked in Portland at St. Johnsbury Trucking until that company went bankrupt. Now he is painting buoys and preparing to go lobstering.

Unlike other areas on the North American coast, where the fishing industry has been devastated, the midcoast of Maine is fortunate—there are still lobsters to be caught. The annual catch hasn't changed very much over time, and 1994 was an especially good year. Still, there are challenges to be faced that did not exist a generation or two ago when Fern and Burt were boys on Vinalhaven, or even when young Bimbo was setting his first traps in the bay. It was a lot easier then to make a living with a small wooden boat and a hundred traps, and you could run your truck down to the shore almost anywhere to dig clams. Now the fishermen are faced with the tough reality that the coast which they thought was theirs has been bought and posted by out-of-staters and fellow Mainers and that they cannot buy in because the price is too high. Except for the anchorage at Bunny Zahn's shore, where there's still not a single pleasure boat, lobster boats are having to compete for moorings in harbors that are aflutter with sails. Soon, too, they may be competing with fishermen who are turning to lobstering because ground fishing has failed.

Even so, there is no giving up. Raymond launched a new boat last summer, a replacement for the one that burned the August before. He and Burt built it over the winter from the pine and oak in their woodlot and fitted it out with radar and loran and power steering. His son has graduated from an eighteen- to a thirty-two-footer. There are more Harvey boats in the bay this year. The Carters and the Harveys are announcing their intention to continue working the seas as fishermen.

❋

The men on the Neck engage in all kinds of fishing: lobstering, scalloping, shrimping, pogeying, and clam digging. Of these, only clam digging does not require the use of a boat. Because anyone can go clam digging who has hip boots, a clam fork, a hod, and a way to get to the clam flats, clam digging is an activity that is associated with the very poor or with ne'er-do-wells who are looking to finance their next six-pack of beer. But some of the fisherman *prefer* to dig clams. Wayne Harvey says he's thinking of selling his boat and lobster gear because he can make more money on clams. (His brother Neil says he'll change his mind when the price of lobster goes up.) Donny Boyington likes clam digging because the shorter work day leaves him more time to build his new house. Norman Carter is threatening to quit lobstering and go clamming full-time. "I'm sick and tired of having my traps cut and my gear messed with," he says.

Local ordinances are becoming more restrictive. The photograph of winter clam digging (page 58) is now history because Waldoboro residents can no longer dig clams on the Damariscotta River. But the clam diggers are unde-

terred—they'll find another place to dig. And if the clam flats are closed because of pollution as the Waldoboro flats were for several years, they believe there will still be a way to dig. "The state will probably let us dig 'em.", they say, "and then make us have 'em cleaned before we sell 'em."

Lobstering, however, is the big industry of the community. The catch has held up over the years but, since there are now many more fishermen and ten times as many buoys in the bay as there were twenty years ago, each fisherman has to work harder to make a good haul. He has to have more traps, an added expense; he pays more for his gas and bait. As always, he is at the mercy of the buyers who set the price of lobster, and that price not only fluctuates but has not kept up with inflation.

As the number of traps has increased, so has the amount of bait thrown overboard from boats. "I expect the lobster will last," Raymond says. "He has plenty to eat." But Fern, who remembers back to when a fisherman had to row his boat and haul hand over hand, is concerned about overfishing. "There's fishermen out there who'll set a thousand traps or more and then they won't fish 'em but once a week, so the lobsters eat each other," he says. Raymond agrees that some fishermen have too many traps but is sure that it would be impossible to enforce a trap limit. "It would be better to shorten the work day and make the fishermen come in by dark like they have to on Saturdays. The way it is now, some guys will stay out until nine or ten at night." He believes that the secret of lobstering is up-to-date gear. "You have to invest," he says. "Otherwise you can't compete."

A newcomer on the fishing scene and a big moneymaker is the sea urchin, previously considered a nuisance because it clogged traps and ate bait. Five years or so ago the fishermen discovered that there was a market for sea urchins in Japan, where they are used in sushi, and that by diving for them they could make an average of $300 a day and sometimes as much as $1000. Suddenly there was a rush to take scuba-diving lessons at the Boothbay YMCA and to buy drysuits and tanks. After a couple of years of big harvests close to home, the catch decreased. Then boats and divers set off downeast in search of fresh fishing grounds. The state has now imposed a size limit and a three-month-a-year ban on diving. Raymond, who keeps his boat in the water all winter now so that he can tend divers, says, "I never thought I'd say anything good about a sea urchin."

All fishing is dangerous, but diving for sea urchins is especially so. The divers go down about five fathoms (thirty feet), usually alone. Although the fisherman tending the skiff keeps a sharp eye out for bubbles, it is often hard to see them because of the turbulence. Once I went out in the *Ellic Joshua* with Irene and Ellic so that she could dive for urchins. She went overboard near an island. The water was rough, and after a few minutes I could see no sign of her. I watched with my heart in my mouth until she finally surfaced after what seemed like hours. There is a danger too that divers will try to cut corners. Lured by money, they may go out in leaky old skiffs, with little diving experience. Already there has been one tragedy and a near-tragedy. George Dyer, a fisherman in the community, broke his neck and was killed while checking his bilge pump on the way to Swans Island to tend divers. And Otto

Miller, Raymond Carter's nephew, was forced to swim a half mile to shore in his drysuit in February after his overloaded skiff capsized.

Fishermen also fish for the fish that catch the fish—bait fish such a pogies, kayak, and herring. Traditionally, fishermen caught their own bait—it was a group effort. If no one went out to net bait, there was no bait (page 95). Now that fishing has become very competitive, many fishermen buy their bait. Dick Hildings, Fern's nephew, runs a bait business out of Round Pond harbor.

Sometimes when you're after one kind of fish your nets may bring in another. Once, when Dick went out after pogies, he caught a ton and a half of bluefish instead (page 109). "We could cut 'em up with a chainsaw," joked one of the fishermen. Instead, they trucked them to South Bristol and sold them whole at twenty-two cents a pound. The next year, Dick and others trapped a school of herring in Muscongus Sound. They netted them and sent for the herring boats that suck the fish out with a vacuum. But while they were waiting, there was a higher-than-usual tide (ten-foot instead of eight). It pulled up the anchors holding the nets in place and all the herring escaped. "When you're fishing, you can't count on money until it's in your pocket," was Irene's comment.

Most of the men on the Neck are day fishermen. An exception is Johnny Morrison, who is like a son to Fern. He has been the engineer on an offshore fishing boat for fifteen years—first out of Rockland and now Portland. I went out to Georges Bank (120 miles offshore) with him for ten days aboard an eighty-six-foot steel stern dragger, the *Fair Try*,

manned by a captain from Portland and three crewmen from towns along the coat. Despite fears about the boat going down or my arthritic knees giving out, I chose to go in April when the ocean was still rough. We went out of Portland in a forty-knot blow and after that it was merely twenty-five knots with twelve- to fifteen-foot seas. Fortified with every kind of seasick remedy, I clung to the winches, the rail, or any available piece of stationary metal, keeping one hand free to manage my cameras and wipe spray off the lenses, hoping not to fall down or throw up.

Johnny, meanwhile, strode the open deck in his hip boots (page 108) without hanging on to anything, though the boat was pitching and rolling perilously. After wrestling with the heavy net and gutting fish for an hour or two, he would take off his oil gear and throw himself on his bunk with his Sony Walkman and Janis Joplin tape. After a nap of only a couple of hours, he was on his feet again. He and the other two crewmen repeated this routine every four or five hours around the clock for ten days. Then, after a scant two nights at home, they set off for Georges Bank again, this time for a double trip of twenty days.

The April weather I experienced was balmy by winter standards. In January the seas are higher and the winds fiercer. When ice adds dangerous weight to the mast and boom, it sometimes also coats the fo'c'sle. Often the boat has to be steamed free of ice when she reaches port. The trip I went on, the nets of the *Fair Try* brought up 62,000 pounds of fish—haddock, cod, pollock, flounder, a few halibut, and some lobsters which by law can't be sold in Maine so had to be taken to Gloucester. It was a near-record catch, bringing in $50,000. The owner, after giving

10 perent of his share to the captain, netted $21,600. The crewmen paid expenses and divided the rest. Each made $4000—the captain $6400.

Offshore fishermen have been able to make big money, at least until the recent decline in the catch and the closing of a portion of Georges Bank. Some have been able to save it and some have not. Will Viola, the forty-year-old captain of the *Fair Try*, has invested in real estate in Portland and bought two camps on Little Sebago Lake. Still, the life takes a toll on his family. "My wife and kids hate it that I'm never home. I can't even go to my son's baseball games. And when I take him out in the boat, he's seasick before we leave Portland Harbor. I don't think he'll be an offshore fisherman."

On Georges Bank, Will looks out to sea from the wheelhouse of the *Fair Try* and counts the years until he retires. But Johnny Morrison hasn't been able to save for the future during his years of hard work—the money he has earned has gone to his family and friends. He has put his three daughters through school and bought them cars and television sets—things he didn't have in his own youth. If asked when *he* will retire, Johnny may answer with a smile, "When I die."

I ask Yvonne Morrison what it's like to be the wife of an offshore fisherman. "I was telling Johnny," she says, "that it's like being married single. To tell you the truth, we were more of a family when Johnny and I were digging clams on Swans Island and we didn't have a pot to piss in. Some wives can't take it—they get divorced. But it's made me pretty self-sufficient. I can even make the cars go. I think it's getting a little easier now with the girls grown up."

"Do you worry about the weather when Johnny is out?" I ask.

"Sometimes in the night," she answers, "the wind starts howling and I wake up with my heart pounding and I can't get back to sleep. One morning I heard on a newsbreak on television that a dragger caught fire and went down off of Portland. I couldn't get through by telephone so I didn't find out until the six o'clock news that night that it wasn't the *Fair Try*."

The fisherman loves his boat. If on top of being wide and steady and maneuverable she is *fast*, there is nothing left to be desired except for her to win in her class at the annual lobster-boat races at Jonesport, Stonington, Winter Harbor, or South Bristol. The lobster-boat race is to the fisherman as the rodeo is to the cowboy. It is part carnival, part test of skill. It is a local person's event. If a sailing boat towing a dinghy strays onto the racecourse, it is greeted with scorn. "They should keep 'em out of here" is the general sentiment.

I have attended two lobster-boat races. At Jonesport I stood on the bank with Fern, and while he was commenting sagely on the sheer and wake of each boat, all I could see was small, distant blurs. At Stonington I was aboard Dick Hildings' boat, the *'Bout Time,* which he had brought over at low tide in the fog from his home port thirty-five miles up the coast. "I never knew there were so many ledges between here and Round Pond," he observed. Family and friends were aboard cooking hot dogs on the grill until it was time for the race. Then we boarded another boat, and Dick took the helm with his seven-year-old

son Christopher. We saw them speed across the harbor in the lifting fog. The *'Bout Time* won in a walk.

Quite often I am asked if the fishermen appreciate the beauty of their surroundings. "Appreciate" may not be quite the right word. It would be more accurate to say that every change in wind and weather and tide, every sunrise and sunset, every storm, every day that's thick-o'-fog is as much a part of them as their own hands. Perhaps they don't think of their surroundings as "beautiful" the way a visitor would. Still, I have sensed a hush aboard a lobster boat as we nosed into a pink dawn. And one of the fishermen might break the silence by exclaiming, "Ain't that some pretty!"

❋

I know there are people travelling the road on the Neck who are shocked at what they see—the junked cars, the clutter, the trailers, the houses in need of shingles or paint. If they shake their heads and say, "These people must be lazy—why don't they work for a living?" they don't know much about the fishermen's lives.

Recently the town voted federal grant money to shingle the houses and put in indoor plumbing, and the people on the Neck are pleased because they too like the creature comforts, but perhaps they are embarrassed and feel slightly demeaned not to have been able to make the improvements themselves. And maybe they don't want the junked cars to be towed away—they need them for parts. I have sat in Fern's kitchen many a time when someone came looking for a tool or a part or a piece of rope, and Fern knew just where to direct them to find it amid what might seem

to someone else to be meaningless clutter. And, while there is talk of tidying up, it doesn't have high priority. Perhaps it isn't that important. "I know how we're seen," says Wayne Harvey matter-of-factly. So does Fern. When a summer person down the road told him she thought his place was an eyesore, he snapped back, "Buy me the shingles then." But later he allowed as how he would let every piece of tar paper drop off first just to show her. In truth, the gentrification of the Neck has brought little lasting benefit to Fern and the others. Their houses may look more respectable, but at the end of the road where they used to park their trucks to go clamming they are now greeted by a flurry of signs saying they are no longer welcome—Private Road, No Parking, No Trespassing.

Life is hard for people on the Neck, and they are not strangers to despair. "There was a time in the sixties," says forty-five-year-old Neil Harvey with some bitterness, "when we almost made it into the middle class. Then things got tough again and it isn't any better now." But the community isn't comfortable with social service programs. Although they take help at times, they don't talk about it—it touches their pride. The attitude is, you can always do something to get by. If lobstering slacks off, you dig clams; in the dead of winter, you get a job in a fish-packing plant; if you can't stand that, you quit and get stumpage rights to your neighbor's woodlot so you can cut wood. Only as a last resort do you accept help. When Daniel told Fern that he might get a federal subsidy to put in a bathroom and a septic system, Fern harrumphed, "I've put in three in my time on my own."

*

Hanging over the Neck like fog that won't lift is an air of weariness. The people who live on the road have been battling for three generations to make a living and keep their families together. The signs of stress are visible as they are in other beleaguered communities: domestic violence, alcoholism, lawlessness. This is the dark side of the community, the recklessness of people who seem to be saying, "Hey, what's to lose?" At weddings and boat launchings and lobster-boat races, the lid is off, as if wild partying and fast driving could make up for the harshness of day-to-day life. "Live fast, love hard, die young," I've heard people say on the Neck, and some do. Fern's two nephews drowned off Vinalhaven. A boyfriend of one of the women was found dead on the clam flats. A young woman hit a post and died at the wheel of her car. Others are plagued with health problems arising from obesity, poor nutrition, drinking, and heavy smoking.

There are occasional arrests on the Neck for speeding, drunken driving, and for the possession and selling of drugs. Fern thinks there might be fewer were there more rigorous law enforcement. "The catch 'em and then they let 'em go," he says, speaking of his own relatives and friends. Some people have suggested that Irene, if she applies for a job as game warden (something she is considering), may find herself in the awkward position of arresting people whom she knows for poaching, jacking deer, or selling short lobsters. Even members of the community who have sometimes been on the wrong side of the law advise her to play no favorites. "You got to take your mother or your son or your grandmother just like anyone else," they say sternly.

Sometimes one member of the community will say of another, who may or may not be a relative, "He's a wicked thief." But if something is stolen or vandalized on one of the offshore islands, it is blamed on a family in a neighboring town. Although eyes sometimes turn to the Neck when things disappear, the assumption of stealing may be unjust. The fact that people in the community don't have a lot of money and that they dig clams makes them vulnerable to suspicion. Although it is legal to dig up to the high-water mark, clam diggers make property owners nervous by popping up at the low-tide edge of their land near sheds and boathouses full of valuables. When a woman in the area made the summary charge that the Carters were always making off with her possessions, Burt retorted, "If she came to find all the stuff we'd stolen from her over the years, she'd find a mighty small pile."

One of the most serious breaches of the law in the community has been drug dealing. Several of the men have spent time in federal prison for trafficking in cocaine or assisting in the landing of drug-carrying boats on Maine shores. The state is a natural for the harboring of such boats because the coast takes thousands of twists and turns in and out of inlets and coves, especially in the area from Brunswick to Mount Desert Island. In the early eighties, federal agents became aware that boats from Central and South America were slipping into Maine harbors in the dead of night to drop their illegal cargo.

At eight o'clock on the stormy night of November 13, 1982, a boat with a Colombian crew carrying up to thirty tons of marijuana was apprehended as she landed at Bunny Zahn's dock. Federal agents had been tipped off and were waiting. They arrested the men on the dock and others who were hiding in the woods, then proceeded to Bunny Zahn's house where they arrested him. Twenty-four sus-

pects (ten Maine residents, six out-of-staters, and eight Colombian nationals) were bused to the county jail in Portland that night. In September, twenty-three of the suspects were indicted. The next February, Zahn testified in secret before the federal grand jury. They concluded that there was insufficient evidence for an indictment. Zahn was cleared. Several years later, two of the indicted turned state's evidence and identified another local man as having set the deal. This man went to jail as did four or five others.

This much is common knowledge. The rest is myth and speculation. The story of the drug bust on Bunny Zahn's shore has a life of its own in the community. After Zahn moved to Florida following the bust, and before he died, there were reports of his being spotted in Maine behind the wheel of a car, or in a diner, or on a boat—like Elvis sightings. Some said he was coming back to pay off the fishermen who hadn't informed on him; others that he was homesick for his old haunts. Almost all the fishermen were fond of Bunny. "He ran a good business," they say, "and used us real good." Some people can't believe that a man who lived 400 yards from his dock and noted the passing of every car and truck could have been unaware of what was planned that night. But others, including at least one who went to prison, believe ardently in his innocence.

✳

Sometimes I feel an overwhelming anger at the failure of society to make it possible for the people on the Neck to carry on their lives with dignity. I am saddened that Sheldon Harvey, who is over seventy, still has to go out to haul in all weather because he can't afford not to. That Rhoda Harvey has a never-ending day-to-day struggle with lupus, a disease for which there is little public understanding or support. That all of the Harveys, who exemplify daily the most admirable qualities of industry and family unity, are barely able to make ends meet. I watch their struggles with a feeling of helplessness. Minnie Harvey is more accepting. She consoles herself with a quote from the Bible: "Christ said, 'There will always be the poor.'" I say, "I hope that in this case Christ was wrong."

I sometimes think about what would make their lives easier. Would it be better if they planned ahead, improved their credit, took out loans, formed a cooperative? Probably. But there is a strong attachment on the Neck to the old ways of doing things, and organizing in groups goes against the grain. Besides, the law of the fair chance—the cornerstone of the community—depends precisely on the ability to respond to the need of the moment. I can almost hear someone saying, "Well, we might go to Bangor tomorrow, but . . . you know . . . it doesn't pay to plan too far ahead." I detect behind the brow of the fisherman a deep strain of fatalism. Perhaps it is the acknowledgment of his powerlessness in the face of wind and tide that makes him accepting of his fate, whatever that turns out to be. Gordon Merry, a fisherman cousin of Fern's, may say "We're a dying breed," but he's not going to rush off to the Capitol in Augusta to lobby to save the fishing industry.

Although life has been hard, the people on the Neck maintain a basic innocence, a willingness to trust. Like many other fishermen in Maine who owned shorefront land, their naiveté has been taken advantage of over the years. In the 1930s, the Harveys sold their sixty-acre salt-

water farm on Swans Island for $2500. Earlier, Sheldon's father parted with two thousand feet of shorefront for $275, the price of the Neptune four-horsepower motor he wanted to buy. But, learning from the lessons of the past, Burt Carter does not intend to sell his piece of shore on the Neck at any price.

<p style="text-align:center">✳</p>

It takes a nimble mind to decipher the relationships between the members of the community on the Neck. Minnie Harvey's twin sister Mina is married to Sam Hildings, Fern's cousin. Donny Boyington, Fern's stepson, is Barbara Harvey's cousin. Bimbo and Norman Carter are married to sisters. Sheldon Harvey is not only Fern's brother-in-law but the brother of his Uncle Willard, his mother's brother. And Ellic, Fern's youngest son, is uncle to Travis and Tamya Carter who are almost twice his age. Fern and Carrie are divorced but have coffee together. Fern and Irene no longer live together but are on the best of terms. And each of these individuals has a unique character.

There is no voice just like Fern's or a dry wit quite like Minnie's or an independent spirit exactly like Irene's. How many families can pile into an open skiff in the pelting rain, thirteen strong, without a hint of bad humor—as the Harveys do? And how many boys, on graduating from high school, are given a boat worth $50,000 on the market—built by a father in the shed out back from his own wood (page 60)?

When Fern and Burt used to truck Christmas trees to Florida every winter to sell, they were a big hit with the retirees. I can imagine the two of them setting up under the palm trees and charming customers with their Yankee stories and Shakespearean turns of phrase. "How's the boat you were building last winter?" Fern might be asked. And he'd reply, "Well . . . pretty good, she's nigh done."

The Carters are a colorful family. They have the reputation of being clannish, gregarious, pugnacious. They wear their colors with pride. Once, when I travelled to Orland with Fern, we ran into a distant cousin named Paul Carter who at the time was bulldozing dirt onto the perimeter of his property so that he could put up a hot-dog stand.

"The neighbors don't like it too much," he said with a smile, "but, you know, I'm one of those goddam Carters. We like to irritate."

Fern is a storyteller, and he likes to reminisce about his early days on Vinalhaven.

"Daddy was very strict about chores," Fern remembers. "If we didn't do 'em before we went to bed, he'd wake us up in the middle of the night and say, 'Time for you boys to bring in the wood.' But one thing Daddy loved was the Blue Hill Fair. One time he woke us up at two in the morning and said, 'Get in the boat, boys. We're going to the Fair.' So we all piled into the *Minnie I.,* Mumma and Daddy and me and Burt and Minnie and Lev, and Daddy got out his brass compass, and off we went in the dark, towing a skiff.

"When we got to the Fair, Daddy gave brother Burt and me each a dollar and said, 'When you run out of money, we're going home.' So Burt and me were going to make that money last as long as we could. We spent a quar-

ter the first day, a quarter the second day, and that left fifty cents for the third. On the last night it rained, and Burt and me were sleeping in the skiff 'cause there was so many of us, and we just pulled a bearskin rug over us and a canvas on top of that and let the water run off into the bottom of the boat. And we didn't even care 'cause we were so happy we got to stay the whole three days at the Blue Hill Fair."

Boats figure large in the stories told on the Neck; hunting and drinking run a close second. Fern tells about a time he went hunting rabbit.

"A while back," he says, "I used to be fierce on hunting. Well, one day me and my dog Duke were out there in the woods and we spotted a rabbit. I took aim and dropped him but, go to pick him up, I heard a baby crying. That's funny, I thought, what's a baby doing out here in the woods? Then I saw it was that rabbit—it was crying like his heart was broke. I finished him off but it kinda shook me up. Since then I don't feel like going hunting any more. Guess I'm too old for it."

Fern tells a story about Burt Dyer, a fisherman. "You know how Burt has that trailer atop the ledge on Vinalhaven," he starts out, "and people coming off the ferry come right past? Well, one day Burt stopped a whole bunch of people coming up the street and told them about a famous tourist sight. Said it was an Air Castle. He was as drunk as a hoot owl. Damned if they didn't all follow him up the ledge to see it. And it was only his old trailer."

Another drinking story is told by its main character, Lionel Stover. "One night," he says, "I was driving down Route 32 on the way to the store. A cop pulls me over, says I'm drunk, wants to see my license, tries to get me out of the car. 'I'm not getting out of the car,' I tell him. 'I'm

sober!' 'No, you're not,' says the cop and tries to open the door. I pull on the handle but the door opens anyway, and I fall out on the ground. And you know," Lionel ends with a smile, "that's how I found out I had a drinking problem."

Some people on the Neck are the stuff of fables. Arthur Pepe (page 72), the trash collector, a bachelor in his fifties, is one. He lives five miles away in Waldoboro with his eighty-year-old mother, but he visits on the Neck when he makes his rounds, sometimes at two or three in the morning. Fern was awakened one night after midnight by the sound of a packing truck scrunching the trash, followed by a knock on the door. He went downstairs to find Arthur already sitting at the kitchen table, ready for a cup of coffee and a chat.

Arthur's favorite topics are his mother and what he calls his "treasures," the items from his trash collections that he can't bear to take to the dump. "My *mother*," he says with heavy emphasis, "takes all my money, and she's always trying to get rid of my treasures." Arthur knows just where everything can be found. Once he disappeared into a mountain of trash and emerged with a box of out-of-date photographic paper to give to me.

Arthur, alas, has been recently caught in the wheels of progress. His mother, under pressure from the town to tidy up her yard, contracted with a junkyard in Bangor to remove Arthur's treasures. The contractor worked for over a month, pressing and hauling off forty tons of junk a day. Fern figures that at seventy dollars a ton they made almost a hundred thousand dollars from the job. "And," says Fern, "Arthur won't see a penny of it."

Like a mackerel sky foretelling a shift in weather, the carrying away of Arthur's treasures is a sign that other

changes are in the wind for the community. Most conspicuously, Loyall Sewall's lobster business has changed. The pounds are leased to a big Canadian buyer rather than being used to store the lobsters caught by his own fishermen. The Harveys have left, dissatisfied, and are selling their catch in Friendship where they are paid a bonus. If Loyall's business fails and is not replaced by another or if the property is sold for residential use, the lives of the fishermen will be thrown into limbo. They will have to find somewhere else to moor their boats, buy bait and sell lobsters—no easy task.

I see change coming, and I worry. I chase my worries in circles and then I voice them to Fern. "What's going to happen?" I ask him. "Well . . .," he says without a trace of humor, "I've just been thinking I'm getting pretty tired of lobstering. I might go into fast food, you know. That's where the money is. 'Course I'd miss the sea, but . . . you know . . . you can always do something."

❋

Since I began taking photographs and even in the course of writing this text I have seen changes—some that I expected and others I didn't predict. Arthur Pepe has sold his trash business. The joy went out of it when the town forced his mother to clean up the dooryard. Being required to separate his trash at the dump was the last straw.

Fern and his brother Burt have had heart attacks. They have given up lobstering. Fern hasn't gone into fast food, but he is making wooden lobster buoys for the tourist trade in his shed out back and taking trips up and down the coast in his new van. After the accidental sinking of her

boat, the *Ellie Joshua*, Irene quit lobstering and became the second woman game warden in Maine. She is posted near the China Lakes, but she hopes to be transferred back to the coast. The Wayne Harveys have had another baby, Matthew, and Karen, one of the twins, is pregnant. Tamya Carter, the little girl feeding her doll on the boat (page 41), is a teenager. Minnie and Sheldon have celebrated their fiftieth wedding anniversary. The road on the Neck has been asphalted. Fern's house is shingled now and sports a blue deck out front. Balsam for wreathmaking is getting scarcer on Harvey land.

Despite the closing of a portion of Georges Bank, Johnny Morrison and the *Fair Try* are still dragging for groundfish in the territory that is open to them—the deep waters off the northern edge of Georges Bank, and the Gulf of Maine. The catch continues to decline. Says Roger Woodman, owner of the *Fair Try*, "Things are in turmoil. It's too bad the government hasn't taken good incremental steps all along instead of drastic leaps that may not solve the problem. But we're still here."

Loyall Sewall died unexpectedly in February. His death unleashed the fishermen's worst fear—that the shore would be sold for house lots and the lobster business disbanded. At first it was rumored that the Canadian lobster buyer who leased the pounds would take over the business; then, more ominously, that the pounds would be torn down and condominiums built where the bait locker and office stand now. But soon it came to be known that Loyall Sewall, true to the concern he showed for his fishermen during his life, had expressed a wish before he died that the business be left in their hands.

Seventeen of the fishermen, including some Carters but

no Harveys at present, will become shareholders and operators of the Bremen Lobster Pound Co-op. This development has stirred varied reactions in the Carter family. Norman Carter, one of the shareholders, says, "We'll just have to work hard and try to get along. I hope the lobsters hold up." Fern: "I'm glad it didn't go to condominiums. But there will be hatreds if people are left out." Raymond, another shareholder: "It's the chance of a lifetime. I feel bad about the others—after all, they are family. I hope there'll be a way to get them in."

Looking ahead, I am torn between hope and apprehension. Thanks to Loyall Sewall, one piece of Maine shorefront has been preserved for commercial use—the fishermen have been given their fair chance. There are lobster cooperatives now at New Harbor, Friendship, and South Bristol, and there is every reason to hope that this one will succeed.

As for Norman Carter's apprehension about the lobsters holding up, it is hard not to worry. Lobstering so far is not in crisis as ground fishing is. But will the industry be able to withstand the assault on it from those no longer able to catch cod and haddock and from more and more efficient boats carrying more and more traps? It is inevitable that there will be more state and federal regulation—something the fishermen hate. There is talk now that licenses will be limited, that territories will be established, and that the overall catch by the American fleet will be fixed. Once the limit is reached in a given year, there will be no more lobster fishing. The days of free reign are over, and what will happen from now on is anybody's guess. Fern says, "I'm glad I'm out of it," but Raymond sees it as the chance of a lifetime.

It's a pity that it is not generally acknowledged that the value of a small proud community like the one on the Neck is inestimable. A quick look around the country and the world gives evidence that communities like it are dying out. The farmers and loggers of yesterday, if they haven't gone on to other occupations, are working minimum-wage jobs for giant companies or are living on welfare. But look at the merits of the way of life I have been documenting. The people have a tradition, a skill, a love of their work. They are self-sufficient, they take care of each other, they believe in family. They are not primarily consumers—they save and reuse. And their method of catching lobsters is not so mercilessly efficient that they ravage the ocean bottom as they make their catch.

If a national referendum were held, I would cast my vote for a culture that is rooted in the land and sea, where power resides in family and community and in wisdom passed from generation to generation.

✻

Since the start of this work and even before, I have harbored the unsettling knowledge that I exemplify one of the reasons that life for the Maine fisherman is harder than it used to be. I entered the coastal picture thirty years ago as a summer person—a come-from-away. Since then I've spent a lot of time in Maine, winter and summer, and I have made lifelong friends. But the fact remains that I am an out-of-stater who owns precious coastal property. I have been many years trying to make peace with this reality.

When my ex-husband and I bought land on Vinalhaven in the fifties, I burst upon the scene each summer full of

warm feelings for our neighbor, Henry Gross, the lobster fisherman who had sold us the land. I noticed though that Henry, when he saw me, did not get out from under his truck where he was tinkering with the exhaust system. We became friends, finally, but it was hard work. The more amazing transformations have occurred when I have been ready to risk something. The trust I extend to my friends in the community by giving them use of our summer island has been returned in myriad acts of generosity and kindness.

I have been photographing on the Neck since 1987, the year of Daniel Carter's wedding. At first I was worried that the pictures I took and gave to people as offerings might offend them. I feared that my view of their lives might seem too harsh. I tried for a while to soften my prints until I realized that I was compromising the truth of what I saw.

I should have had more confidence in my friends' stout opinion of themselves. When I had the first show of the work at the Farnsworth Museum in Rockland in 1989, the fishermen and their families turned out in force—proud that a record of their lives was up on the walls for everyone to see. And in the spring of 1992 many of them drove their cars and trucks into town for the opening of another show at Radcliffe College in Cambridge. I was honored by their presence and took it to be the highest possible tribute to my work.

I have been held to this work by the effort to achieve a balance between my subject and my craft. When subject matter is compelling, it tends to overwhelm photographs or to relegate them to the role of illustrating a point: This is how a lobster fisherman hauls a trap; this is what a dooryard with junked cars looks like; this is how a balsam wreath is made. In Maine the terrain is land mined with clichés—the weathered house, the stack of lobster traps, the boat riding at anchor in the fog. To break through to a deeper layer of observation and to translate what is seen into a photograph that stands on its own as a picture has been my challenge.

Up River is born of a desire to see the world as a united and harmonious place. I am aware of course that my vision is at odds with what I read daily in the newspapers and observe with my own eyes. Division and discord are rampant, and the prospects for our planet sorting itself out in a sensible way often do not look too bright. Wanting to make it right, I feel at times overwhelmed. I am the anxious listener at the lecture who raises her hand to ask, "What can I do?" I see the lecturer leaning over the podium and saying in the pleased but tired voice of one who welcomes the question but has heard it many times before, "Just do the one thing that you do best." What I do most, if not best, is to try to rid myself of loneliness by poking around in the dark and dusty corners of my ignorance, using my camera and pen to make a record. *Up River* is the record.

HOME

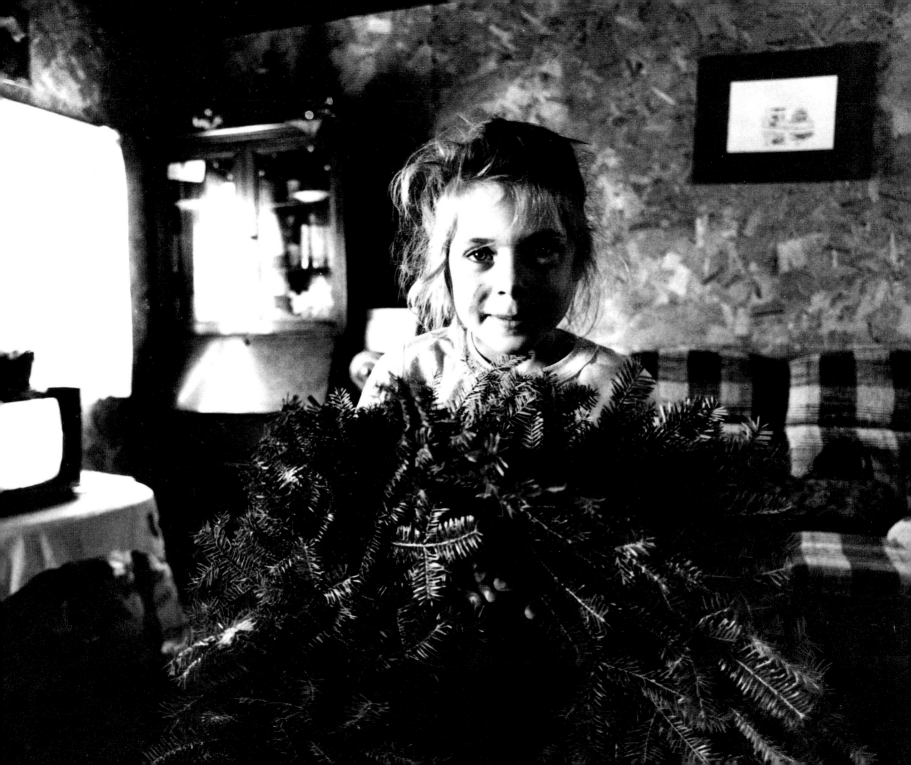

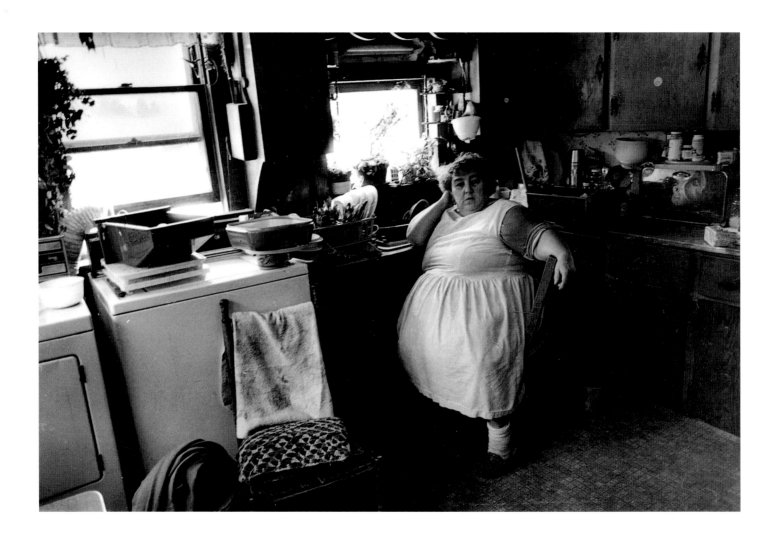

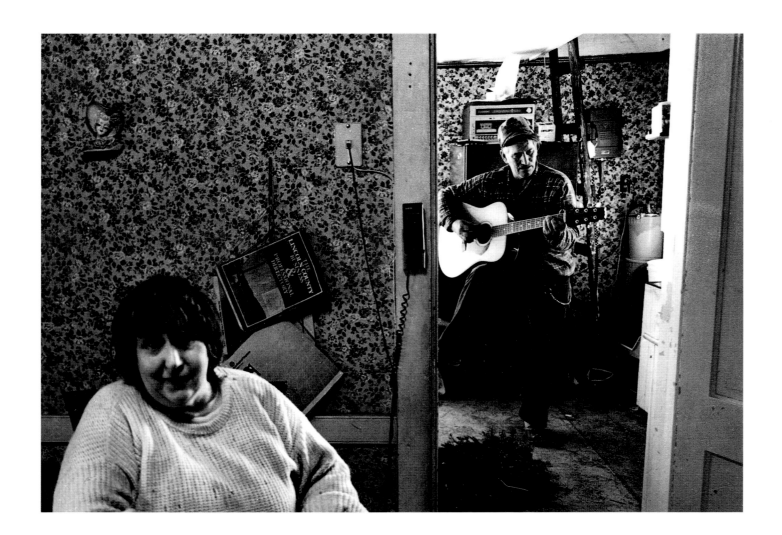

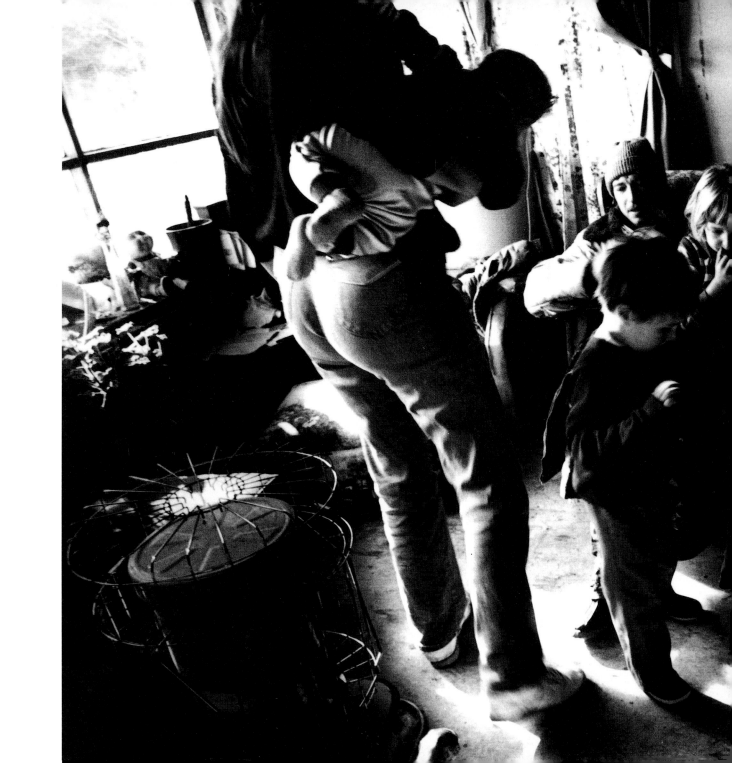

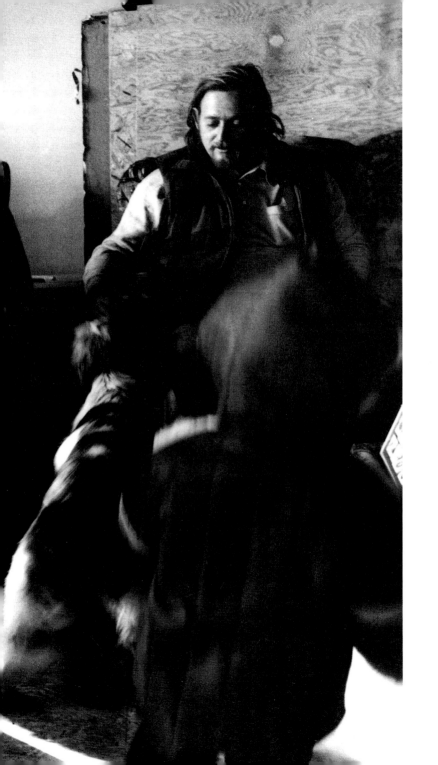

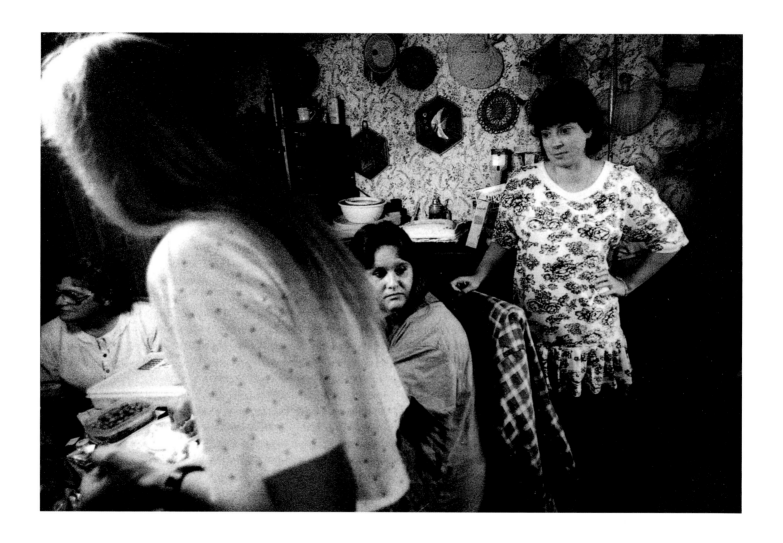

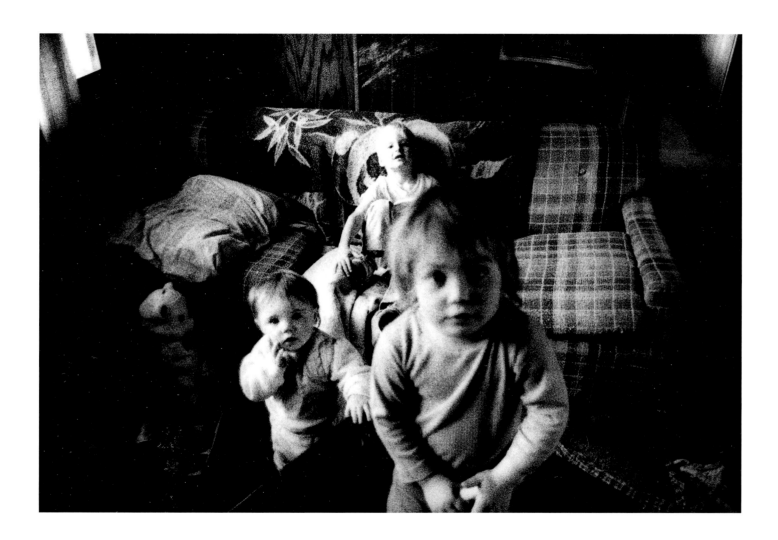

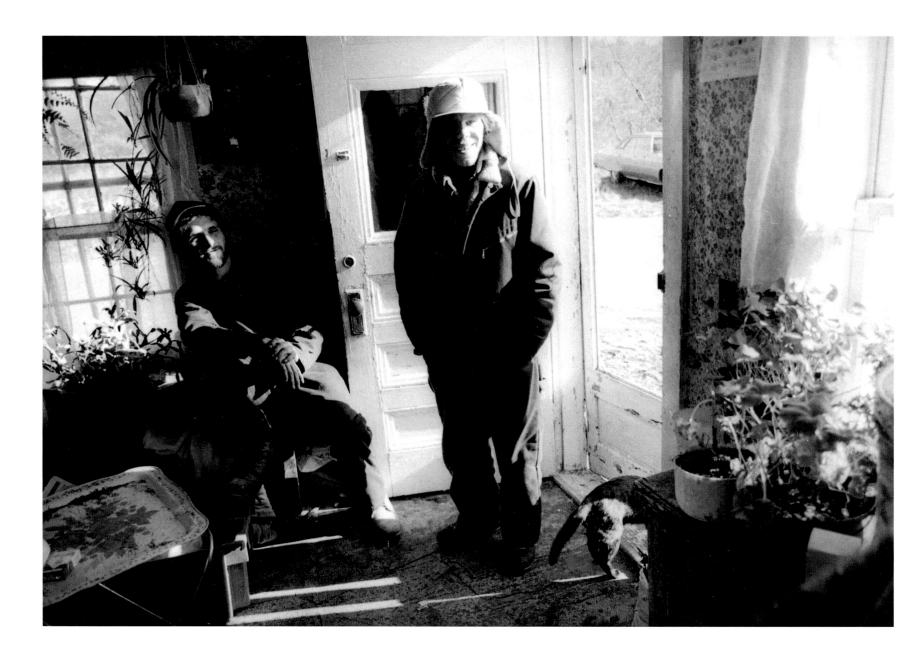

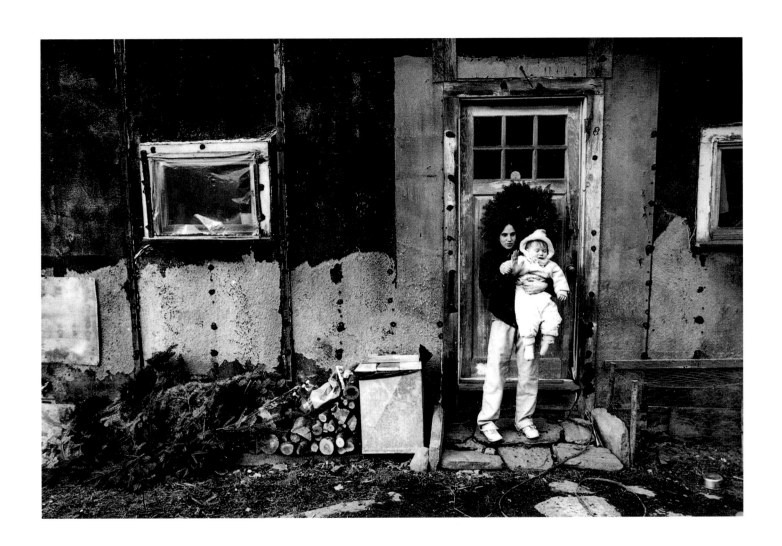

Some call home by a number. Door numbers. Phone numbers.
Don't that tickle you?

Is it gold and far away?
Is it had by learning the new "better" ways?
Or is it flappy, plump, easy, warm and dear?

Love isn't the dance, nor the teeth, nor the
clothes. Love is not two, well-formed, easy
on the eye. Love is heavy with plenteous cries,
the weight of land. Place in common, history
in common, work in common, fear in common,
tiring smelly children in common,
enemies out there with their unfamiliar racket,
yes enemies in common. All of this, wrinkling
and scarring and hard as hell.
There is no love in paradise.

THE NECK

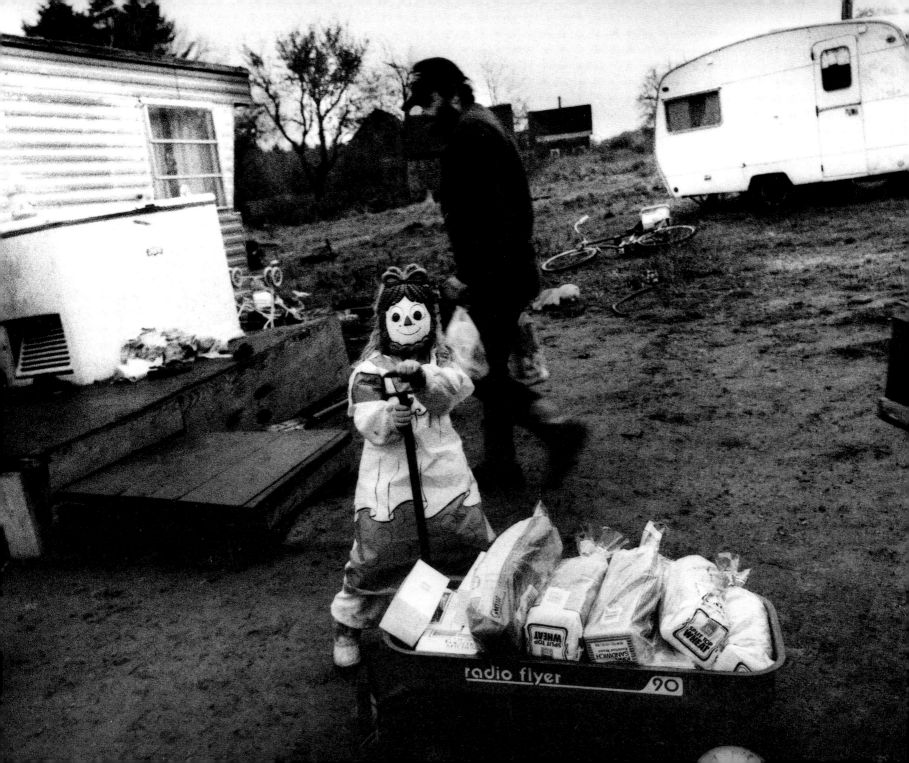

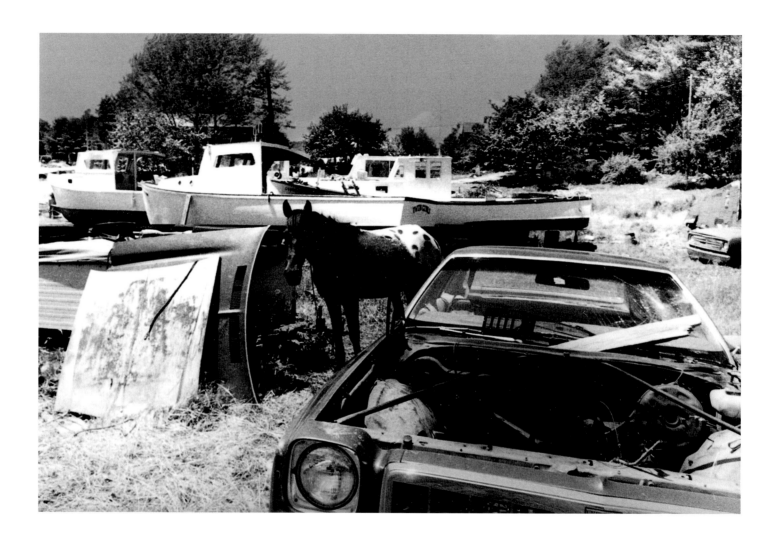

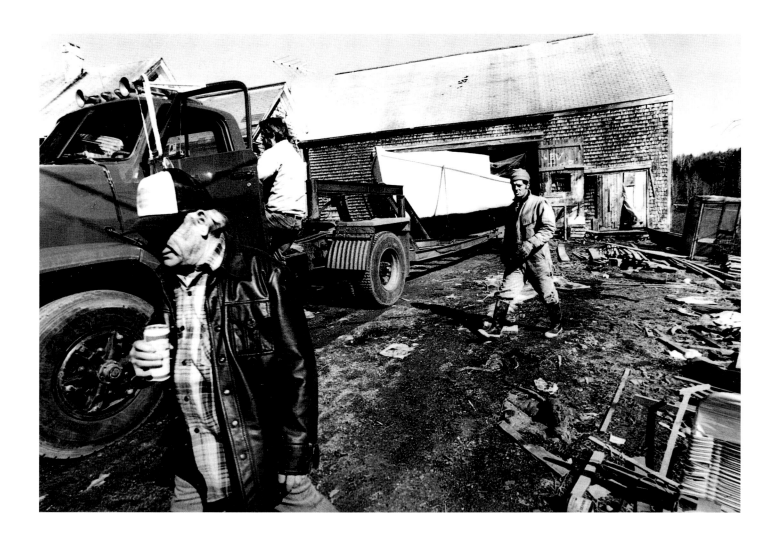

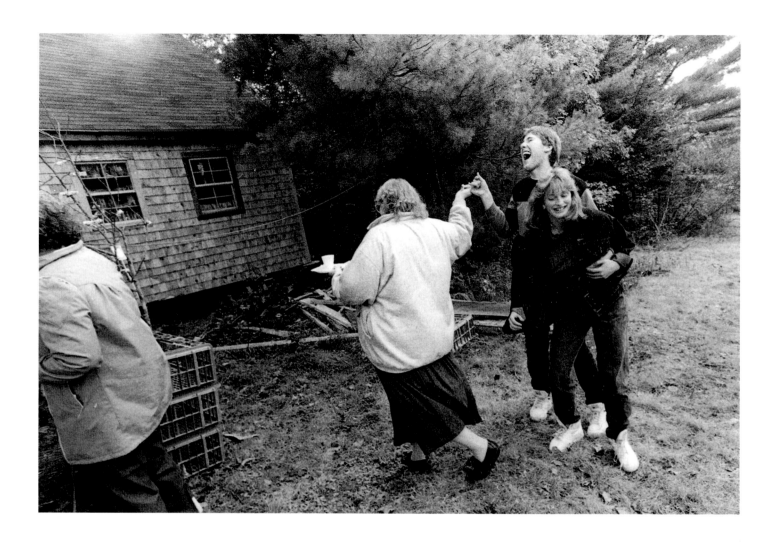

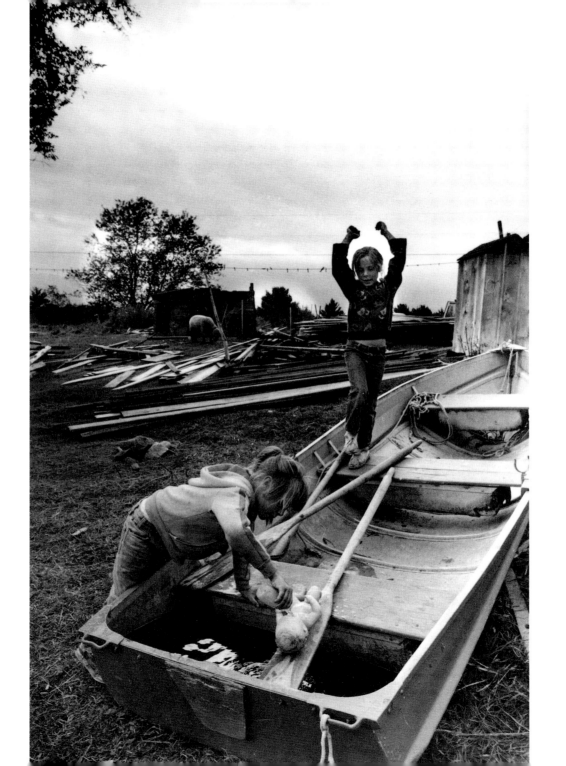

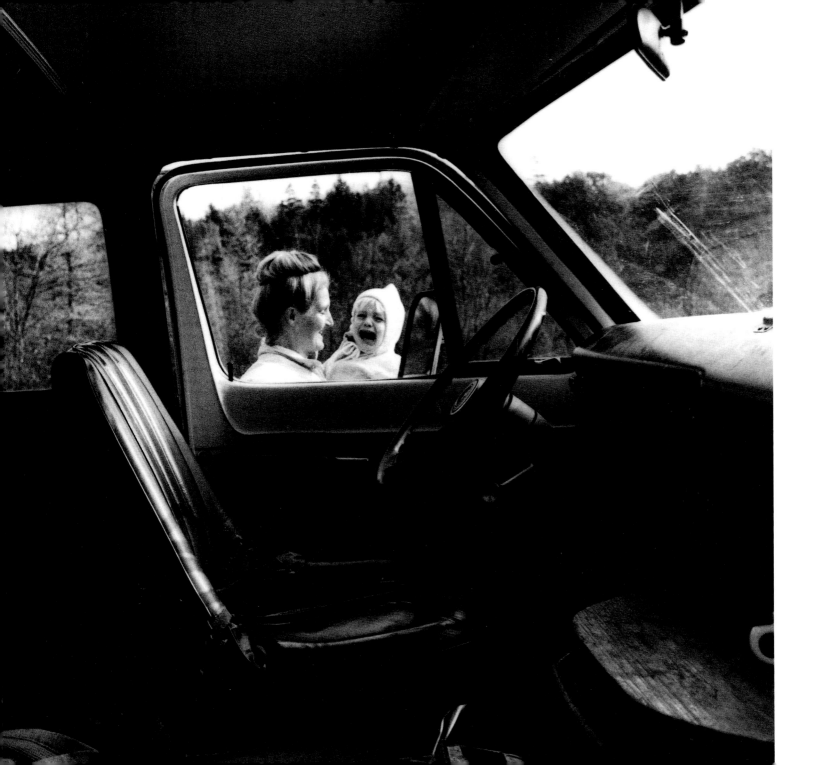

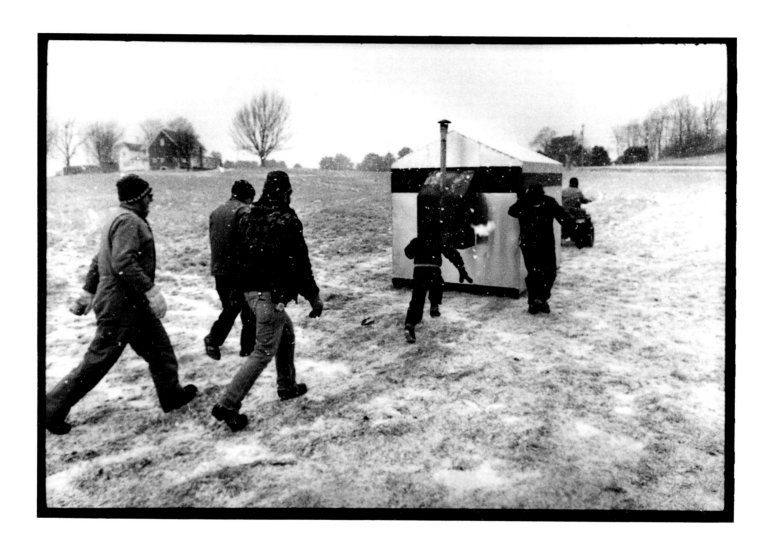

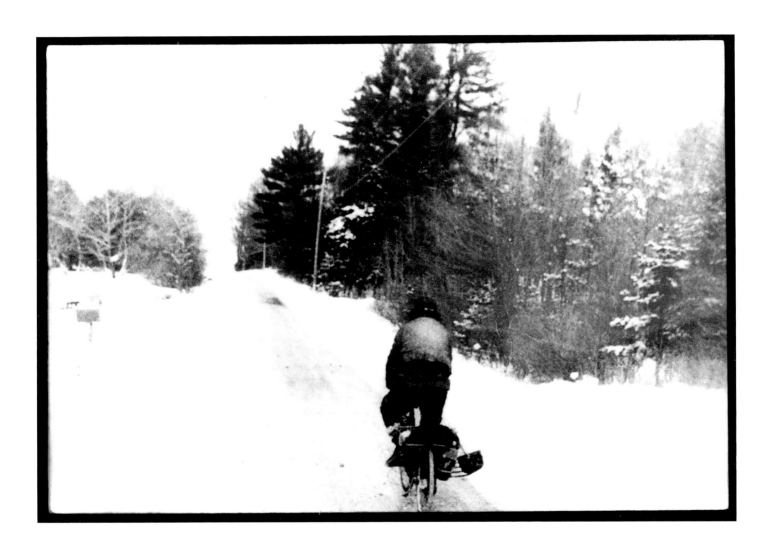

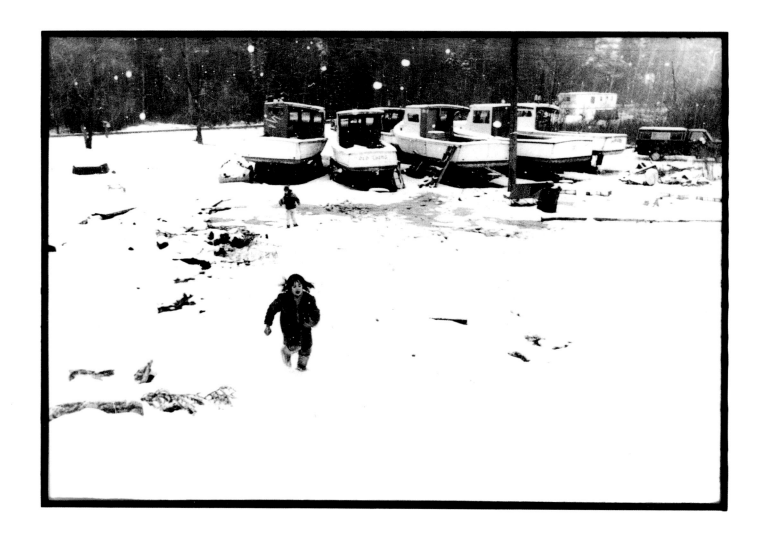

46

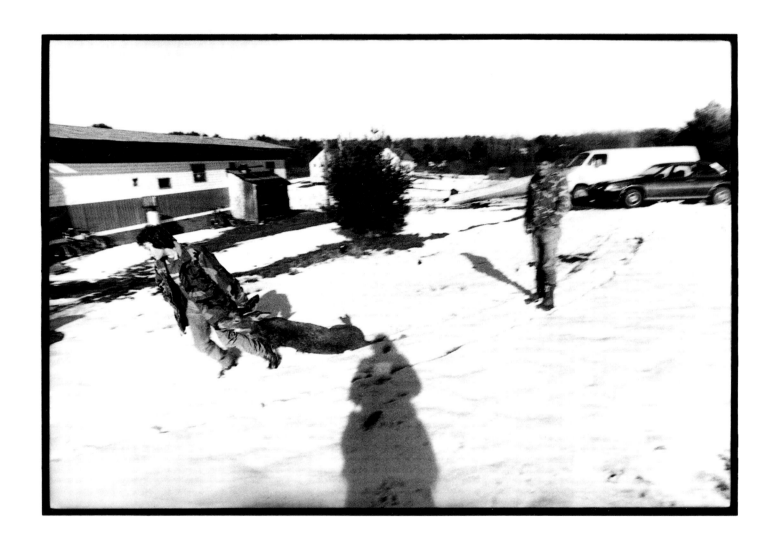

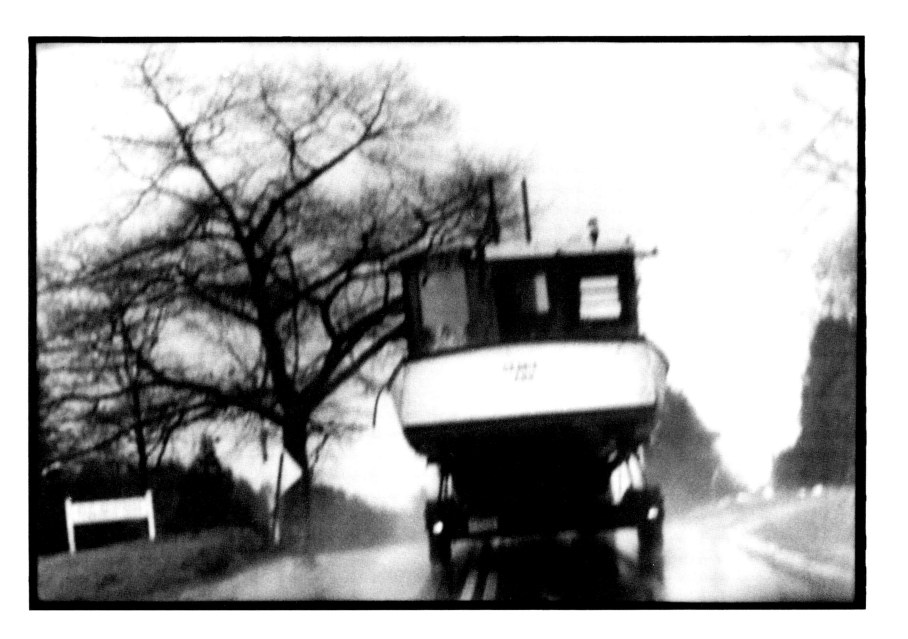

Whatever fic'tous
tassle-triffle you dab-to,
dye-glue or cut free, the
old thing will still
beautify you.

Remember when you were a little kid?
On gloomy days, the fog horns mooed like huge sad cows
and you would see the clothes hung on the lines like
broken people.

We were filled with industry,
the air prickly and
munificent. I do not forget
the sound of my many nicknames
and theirs. I have only
forgotten the arrangement of
furniture, the design on a
blouse, a thread or a fray.

Without land, without a people and
a history, you are a pauper. A fact of life.
You cannot replace these with trinkets and
little pretties and paper things
that count as laws.

WORK

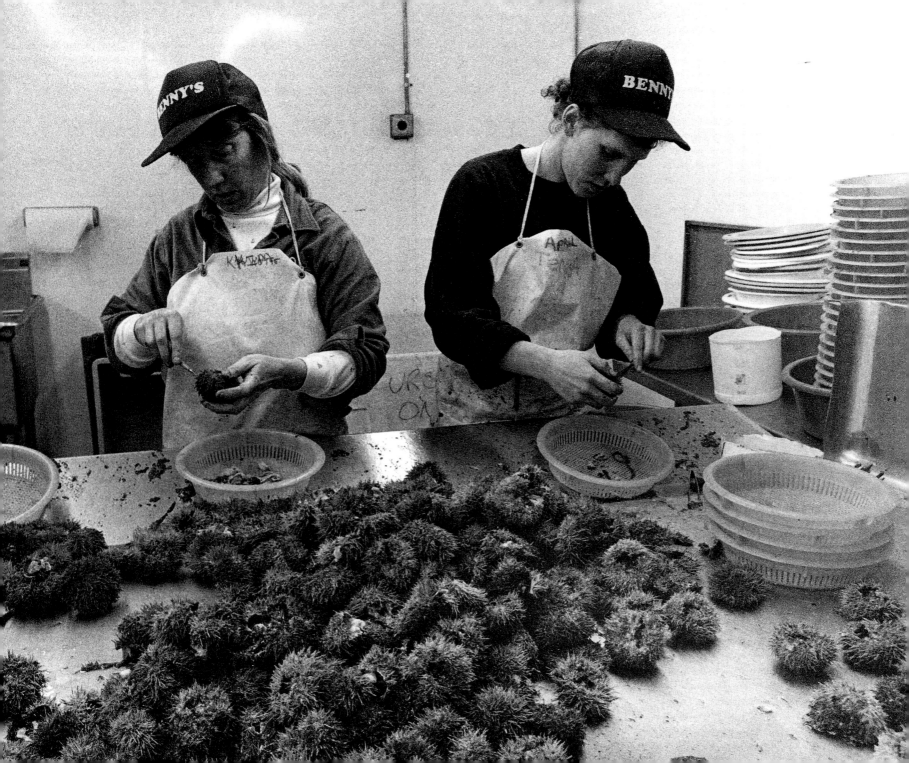

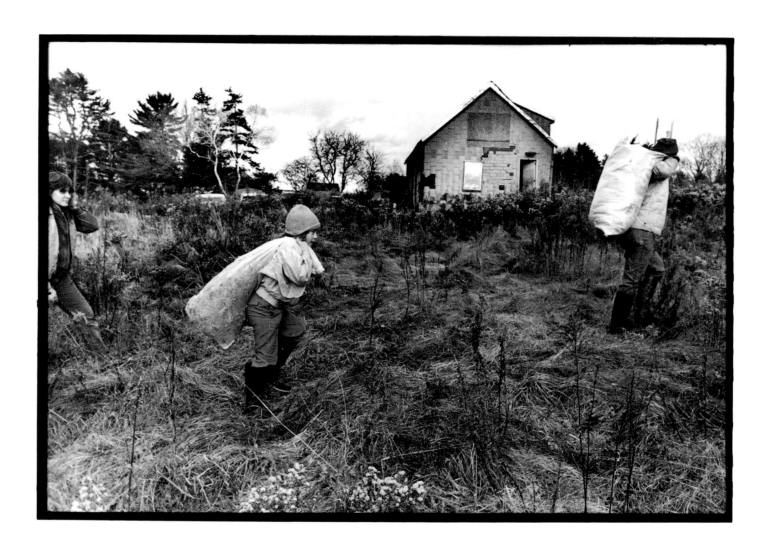

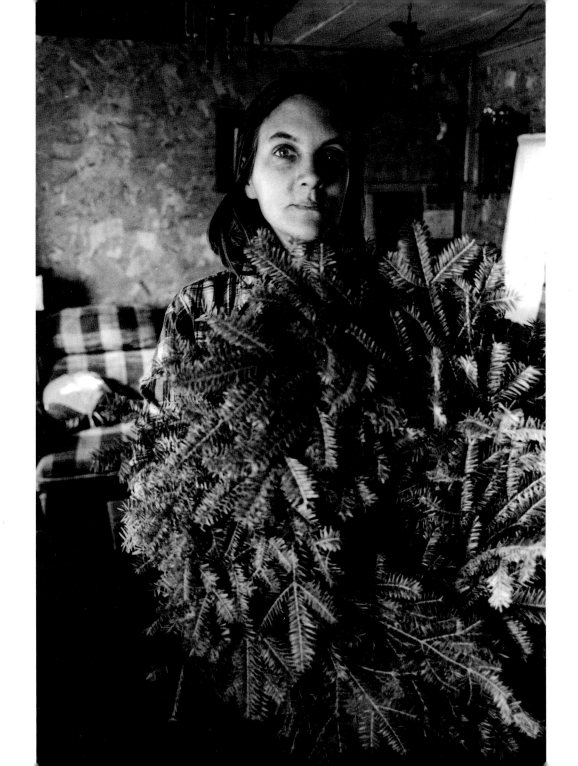

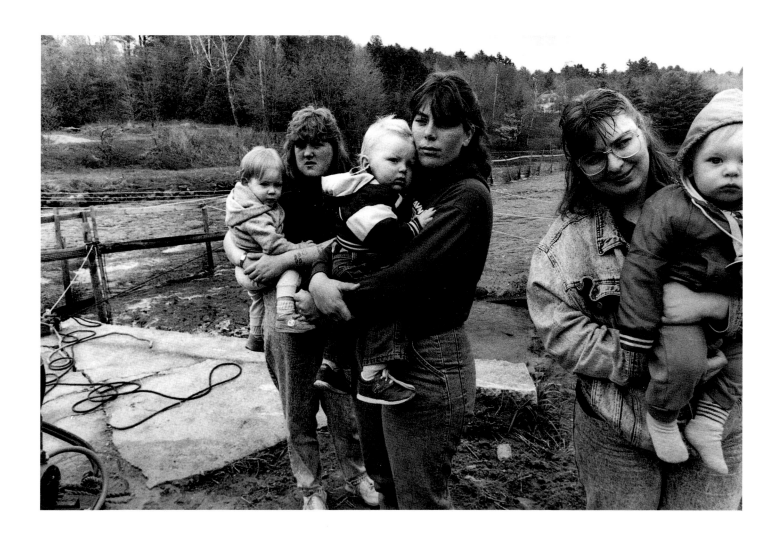

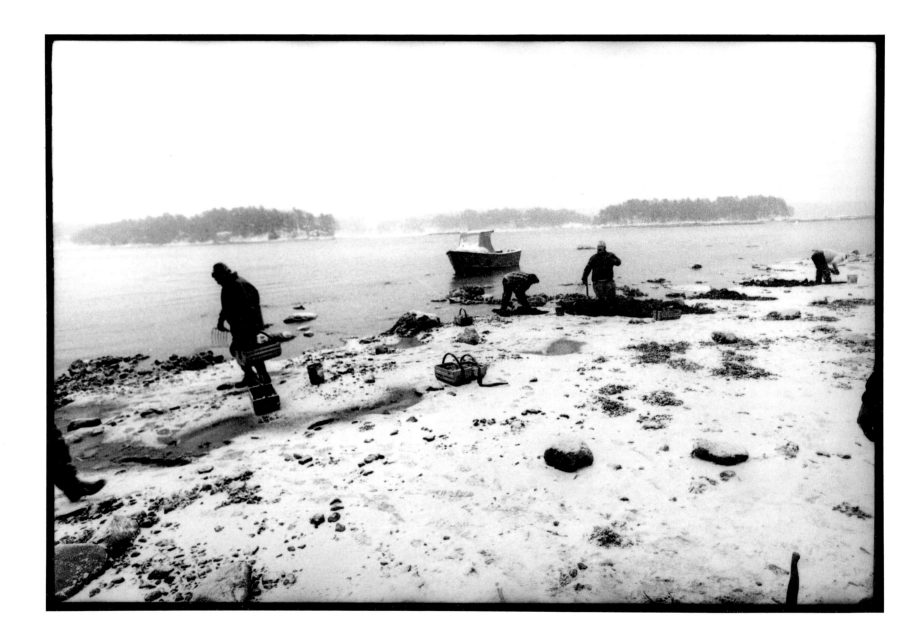

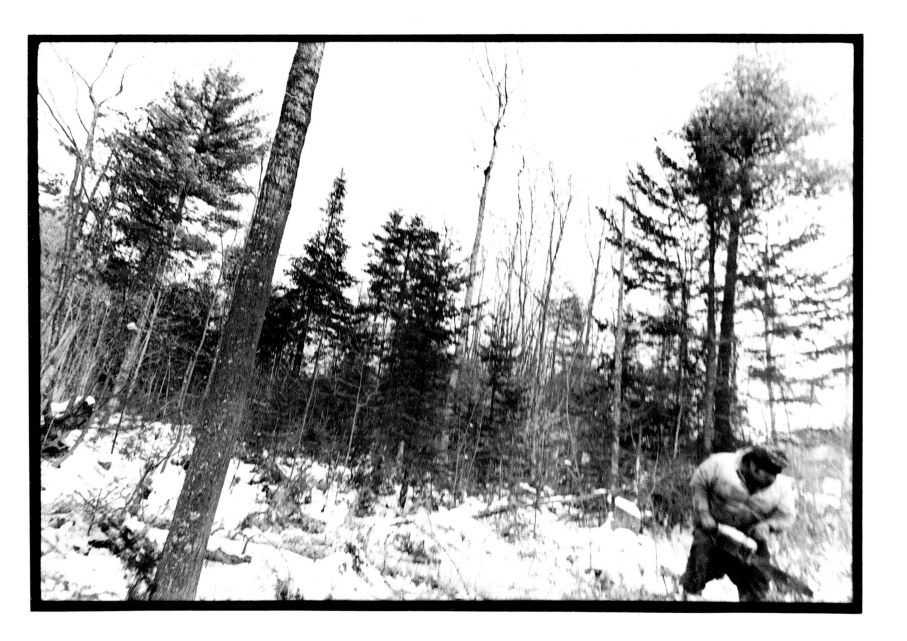

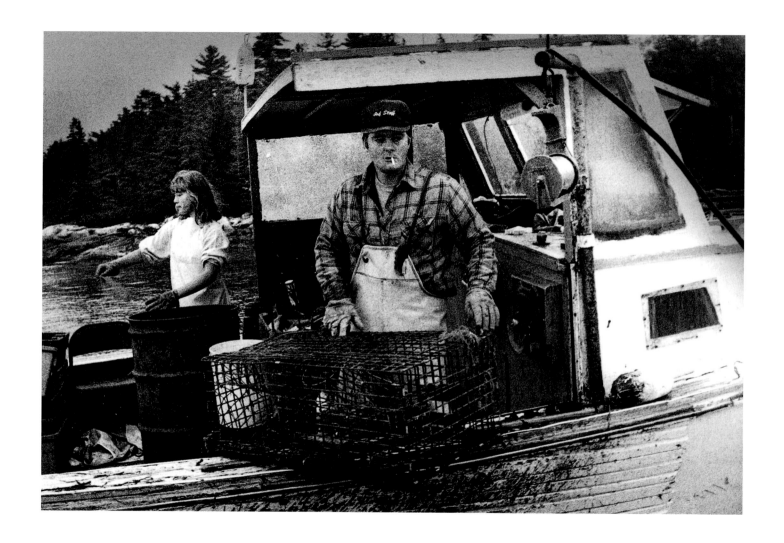

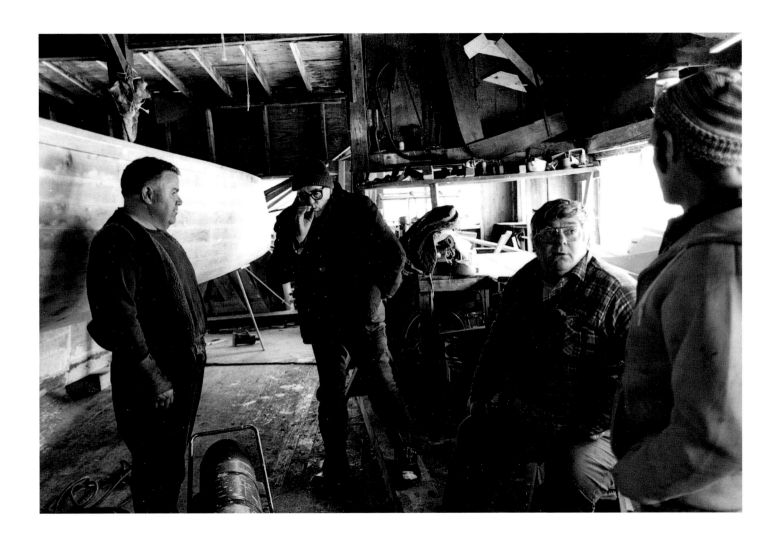

In this never-ending rhythm is
your sudden death, no exploration, no wriggling,
no surprise. You may count on gossip, teasing, a
smoke. A raise in pay! But none of these will
be enough. The clock is in your throat. The sun,
it never was. The day long
and thin as a thread.

I closed my eyes and saw a future of children
kept in ranks of desks, ranks of identical
expectations, thousands of pairs of hands
trained to the keys, and they called it "good."
I opened my eyes and saw it hadn't happened
yet. I saw instead the child
who could still be called a "King" in his way.

Oh, creator, oh fashioner!
Credit the eye, credit the hand, credit the tool.
Crabbed and headstrong god of the self.
Who to thank?

WOMEN AND MEN

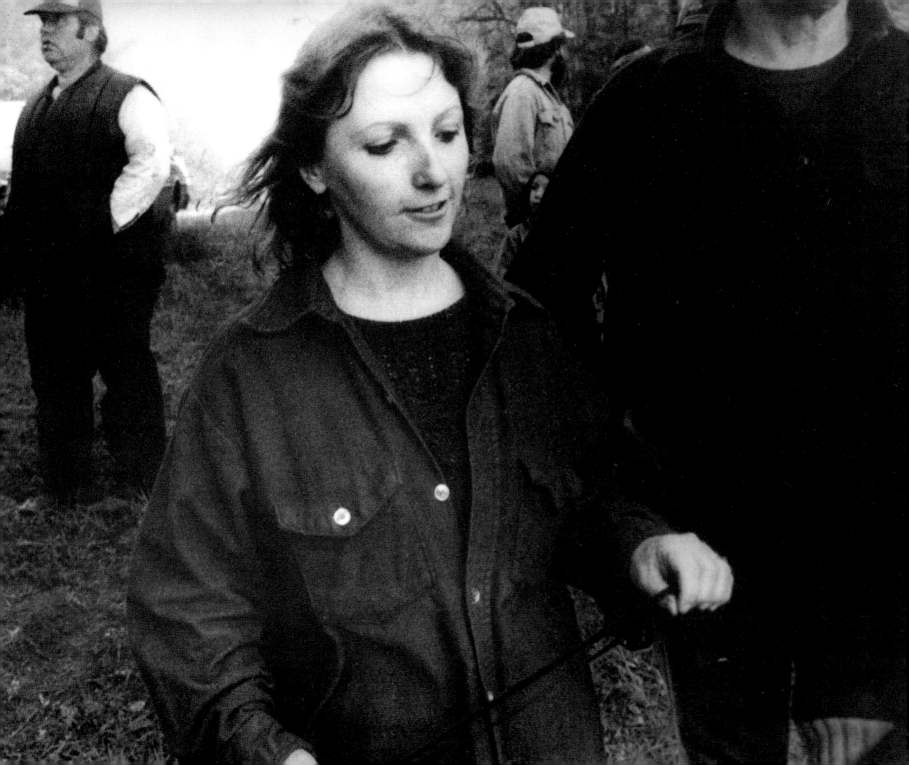

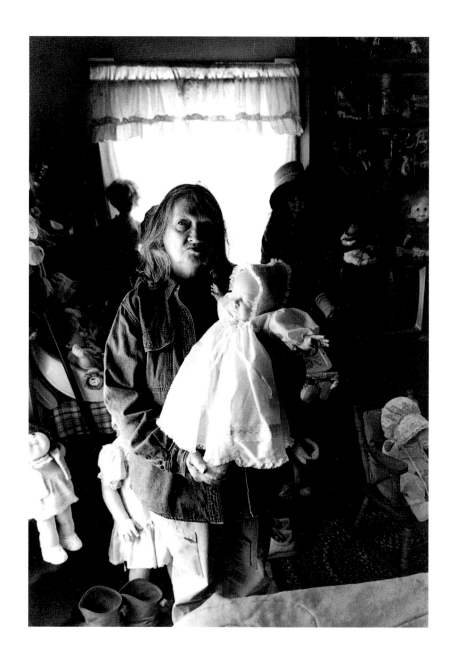

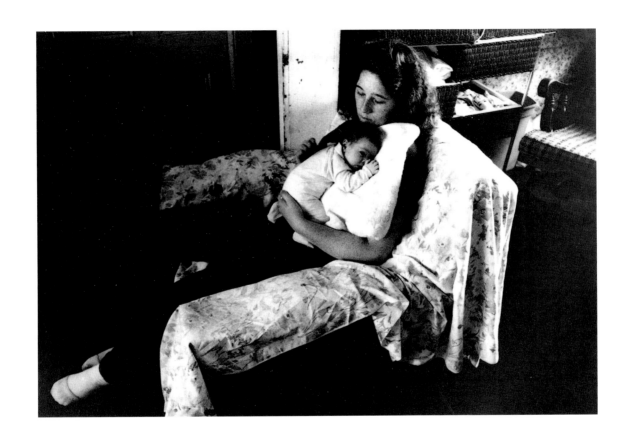

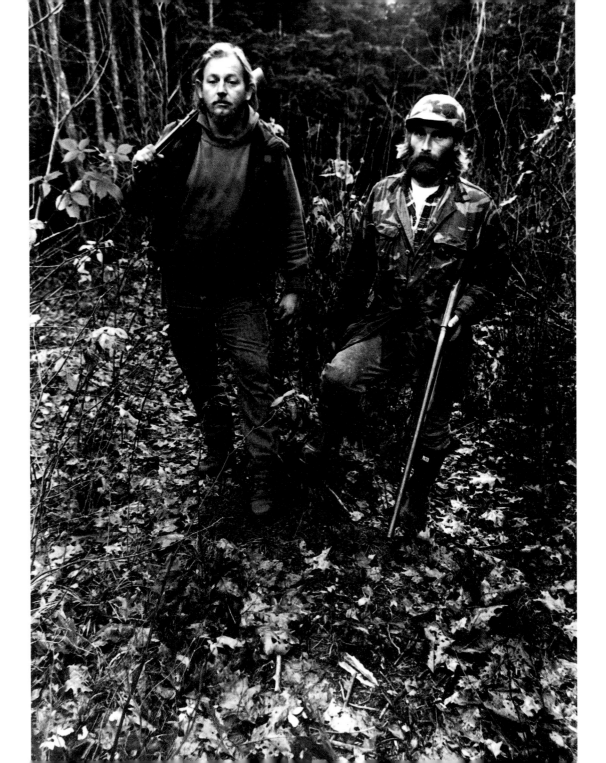

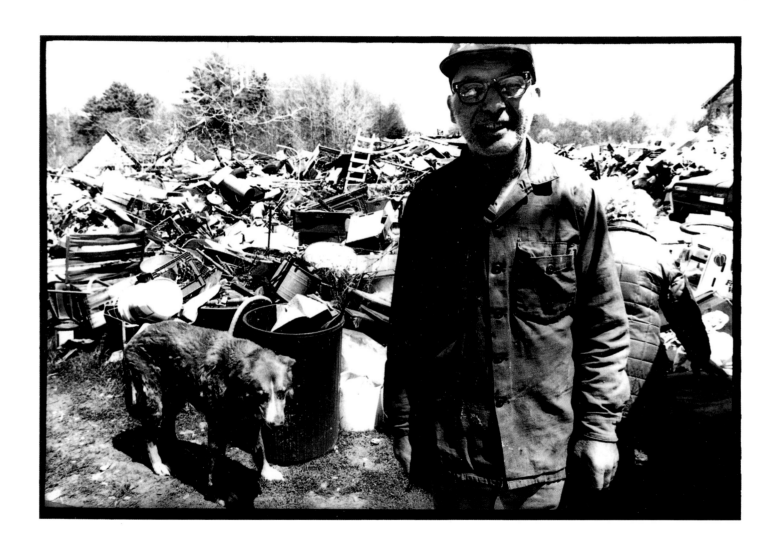

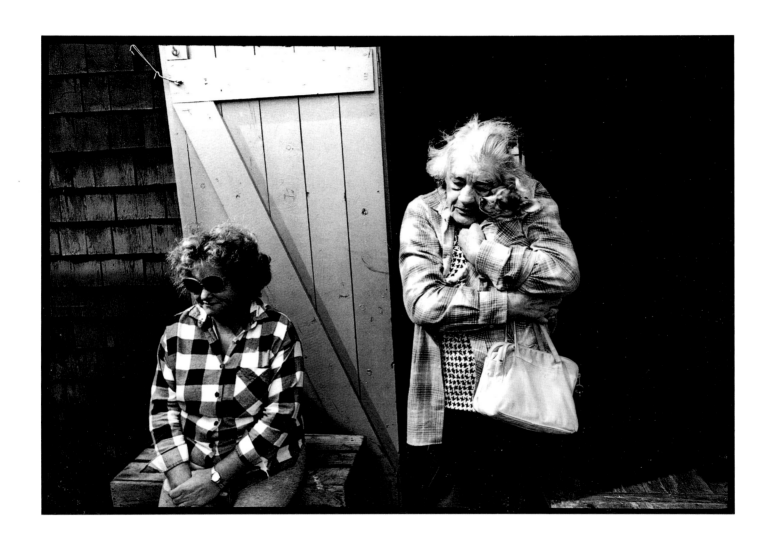

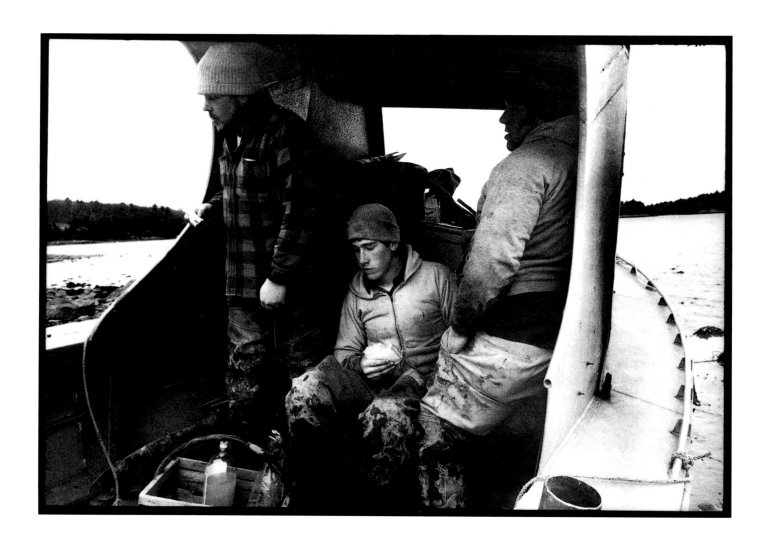

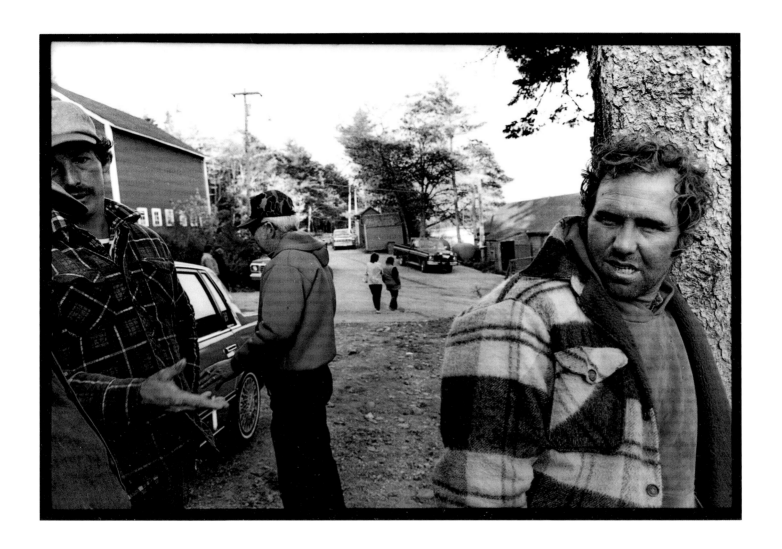

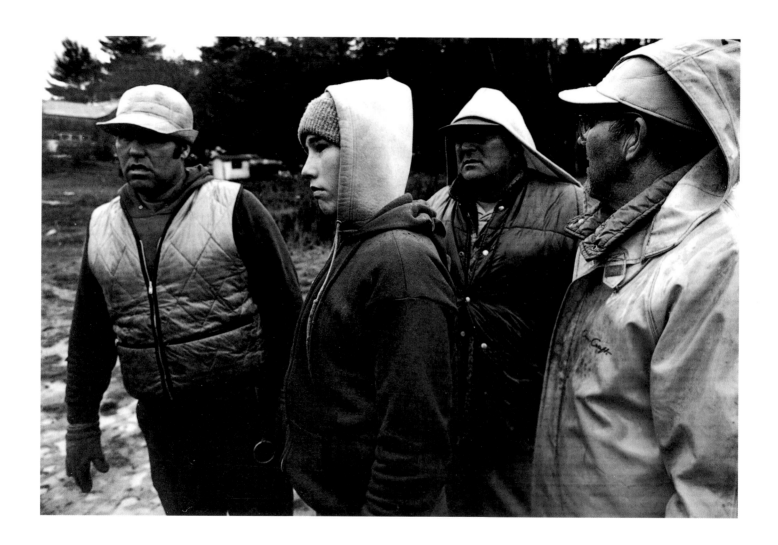

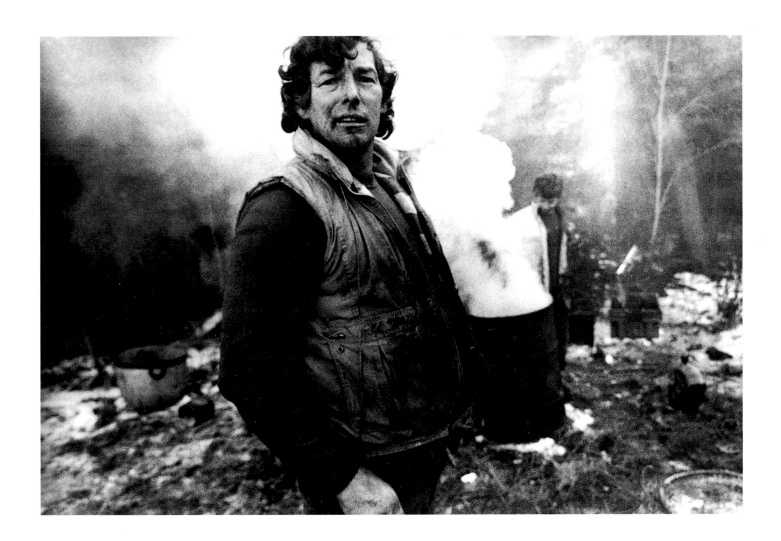

In the shadow and in the power
of named and unnamed lives past,
fathers, grands, greats, and fore greats,
I am easily coaxed to dilly dally.

Say what you will. Women're old. Older
than fire. More fathom-some than sea. More
rangy than universes. More facet-some than big
jewels. Harder than you'd favor. Floppish
and flushish. Mustered and rallied.
But never free.

FAMILY

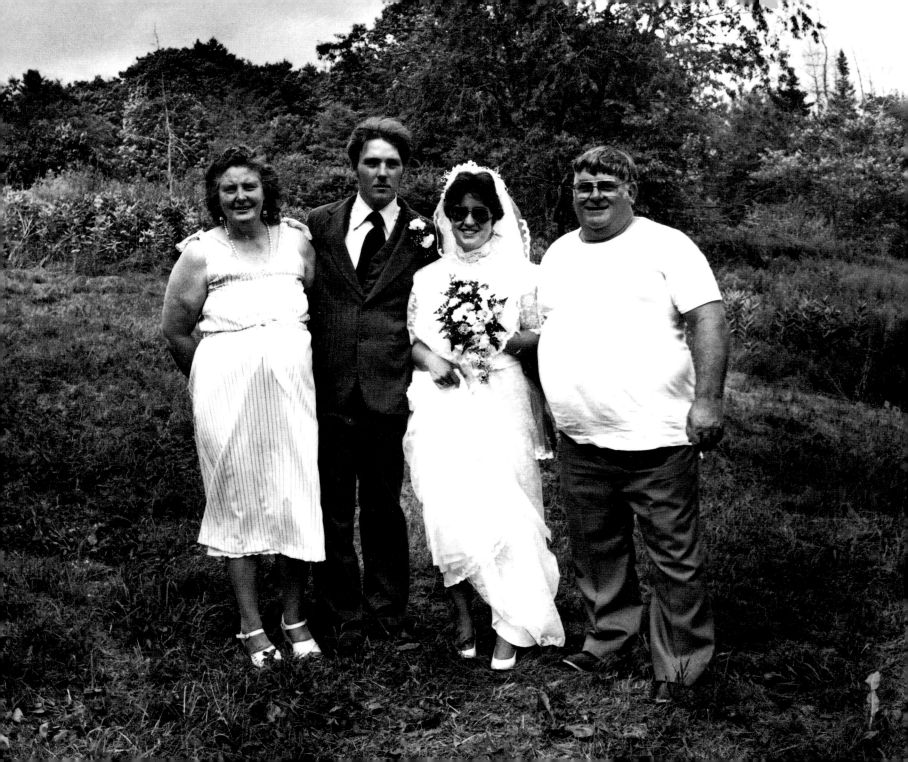

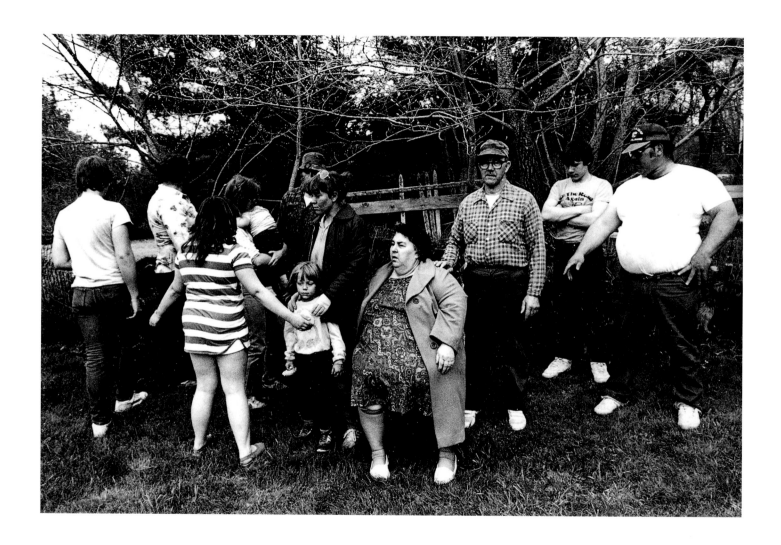

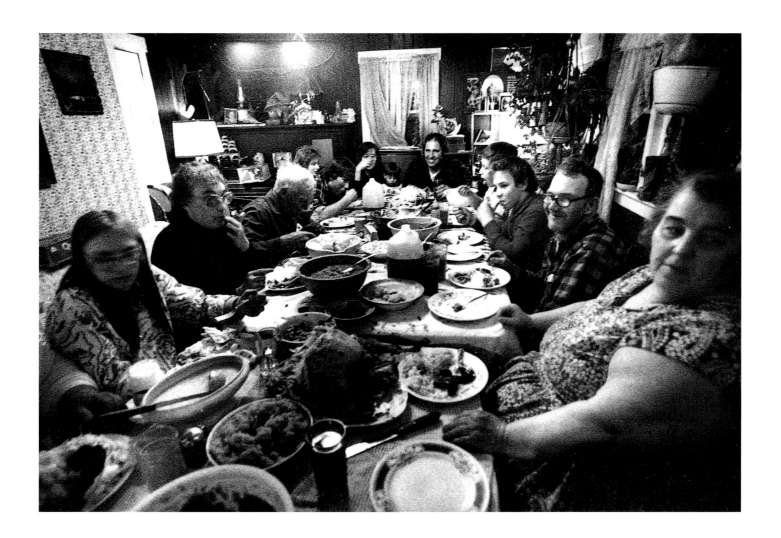

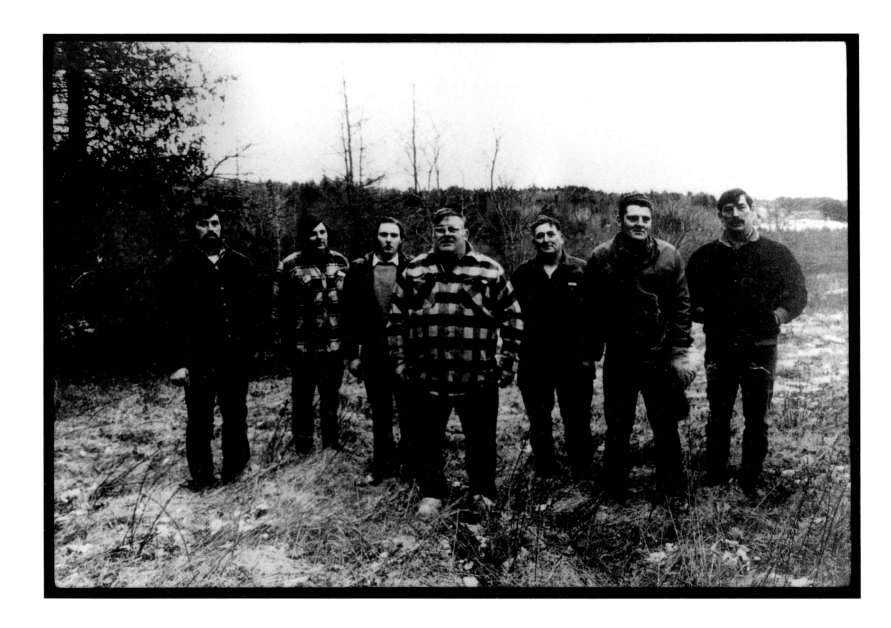

84

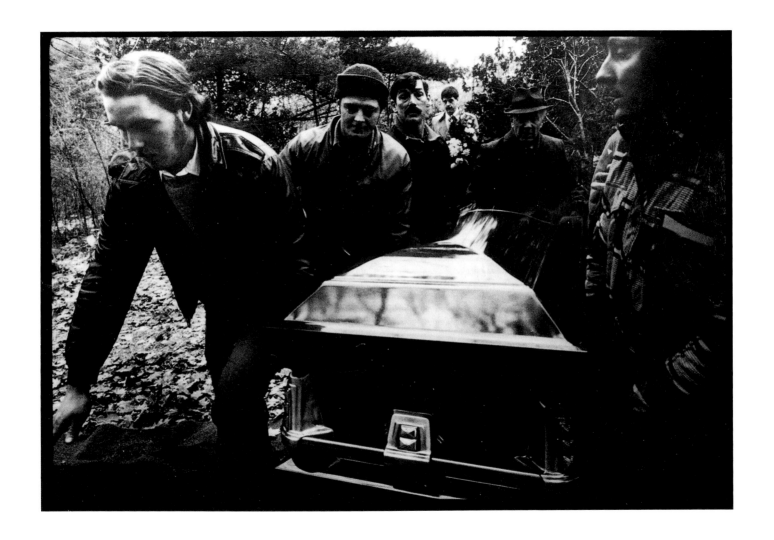

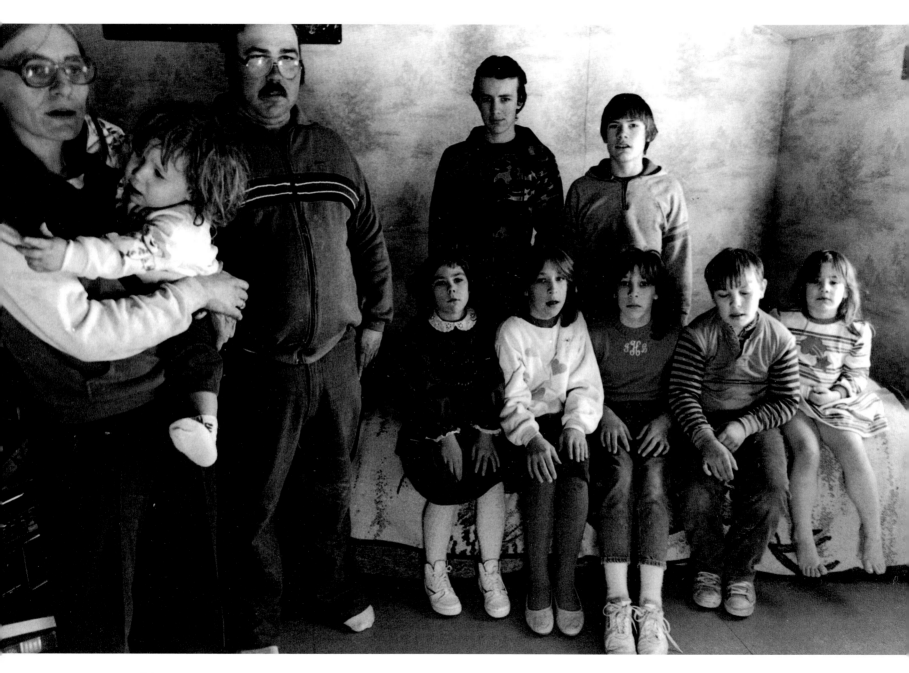

Love is need. The snail loves the smooth.
The owl loves a vista of changing shadows.
The family man loves his brother.

This is a chorale, not a solo.
This is the thunder of our quiet ways, our rowdy Saturdays,
our clocks wound tight out of duty.

You, infant, you are cradled fiercely, and all your questions
 answered in solemn final tones. This is God.
Someday you find there never was a God other than that fierce grip.
We search all our lives for the giant. We weep.

THE SHORE

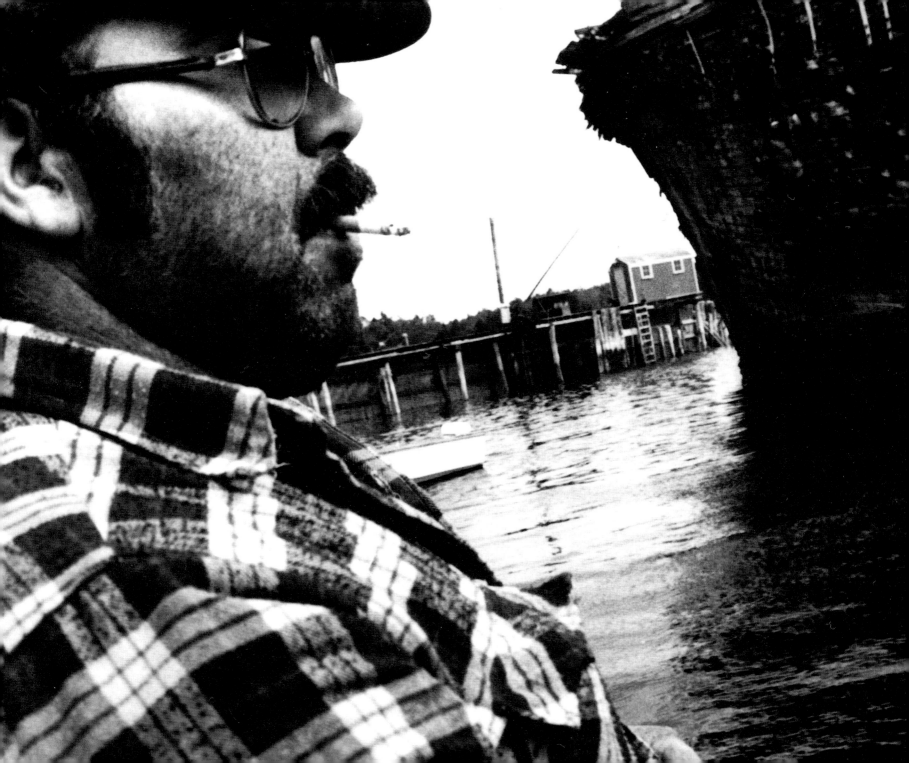

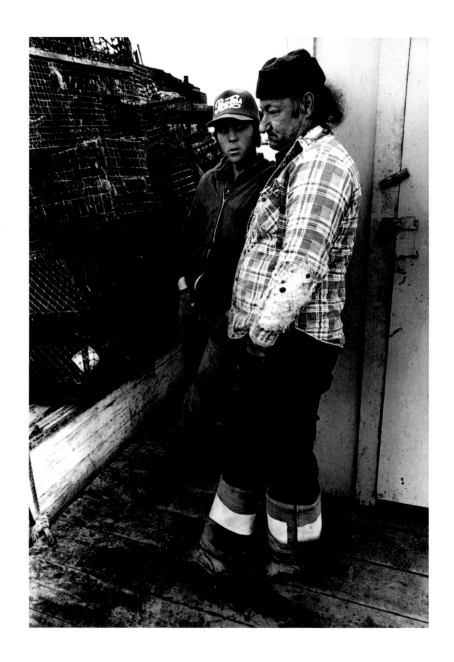

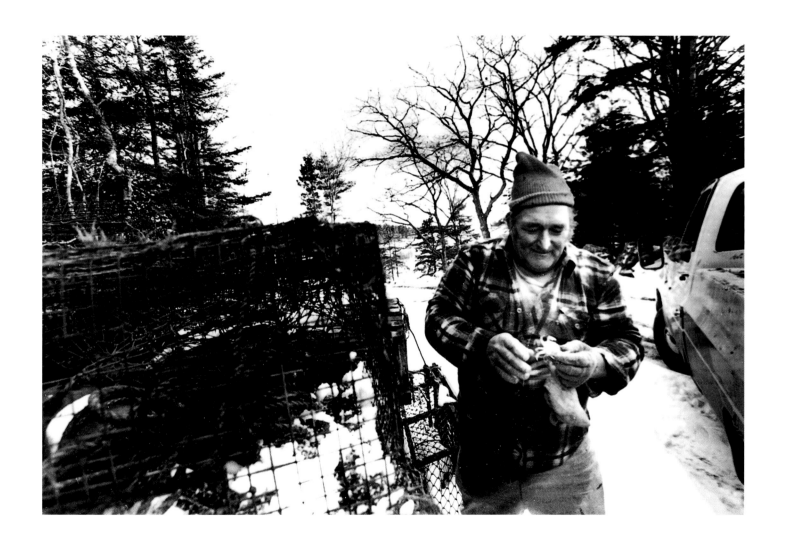

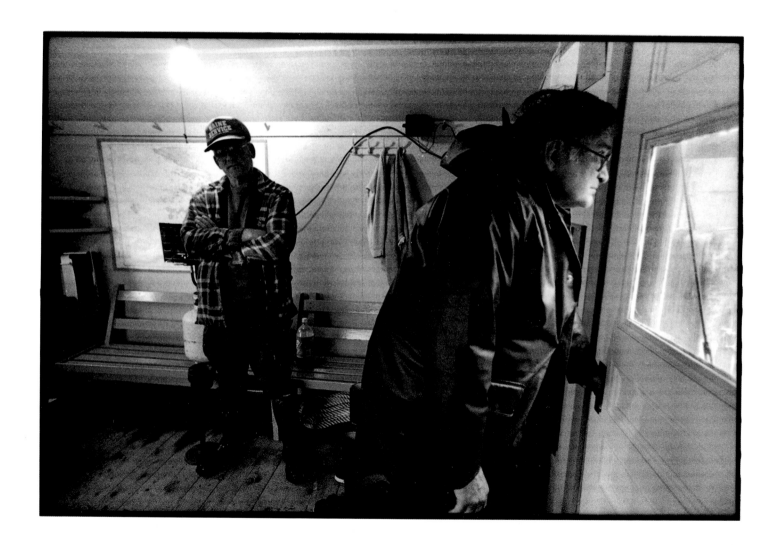

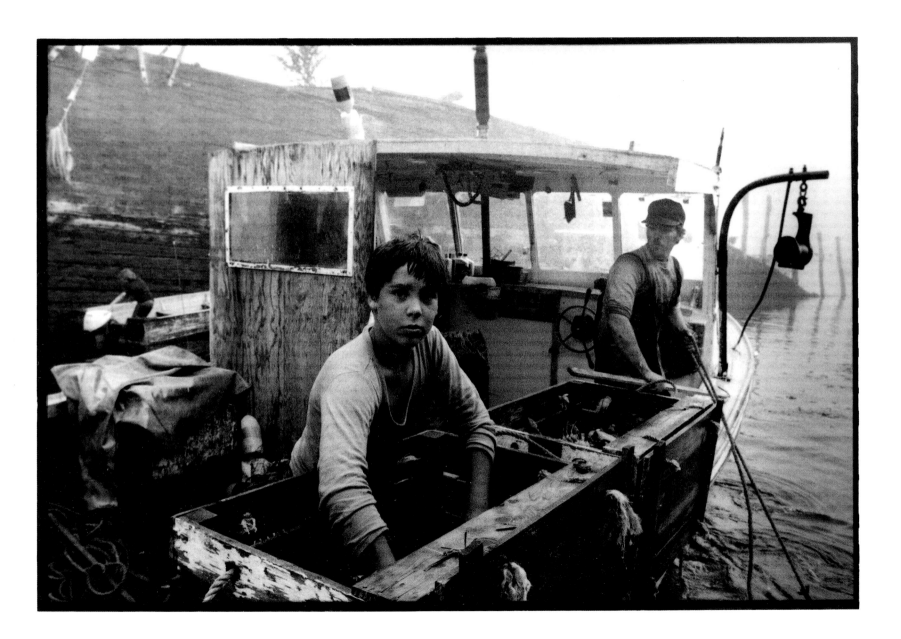

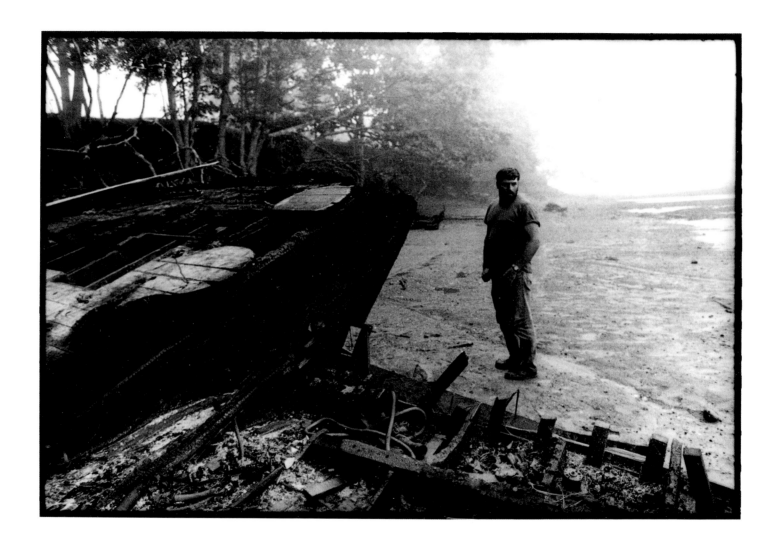

It is causative. The clues are
everywhere. Opportunity in
certain dark interstices.
In each of my genes a thousand
years of boats. Small ones of
course, like seeds of grass.
It is nothing!
No applause please.

The new day is ready and waiting.
The "premiere"!
All possibilities under this web of silver and glass.

OUT TO SEA

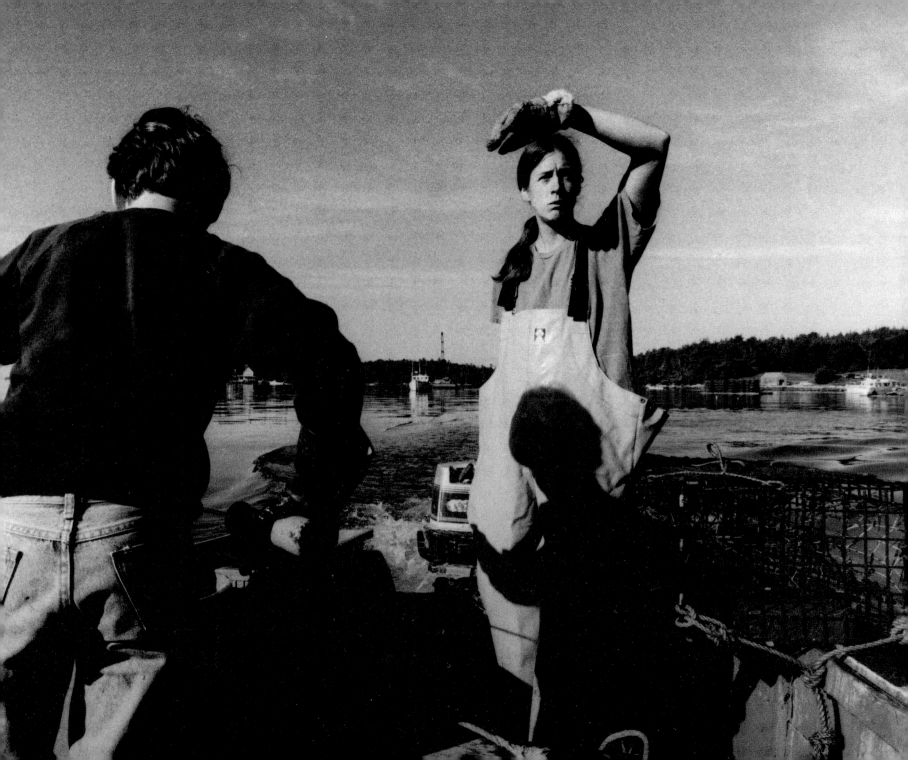

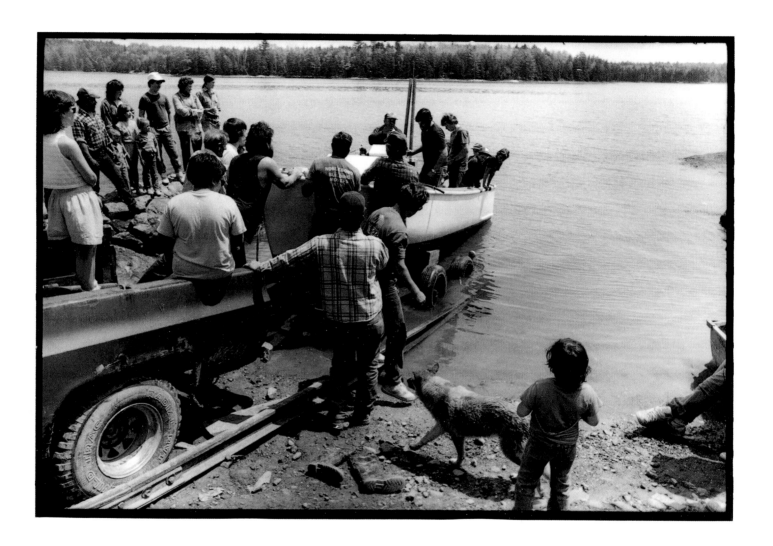

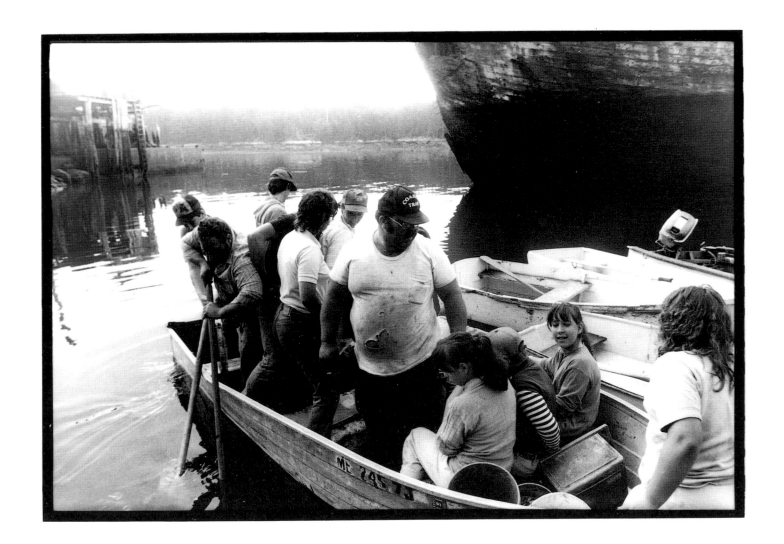

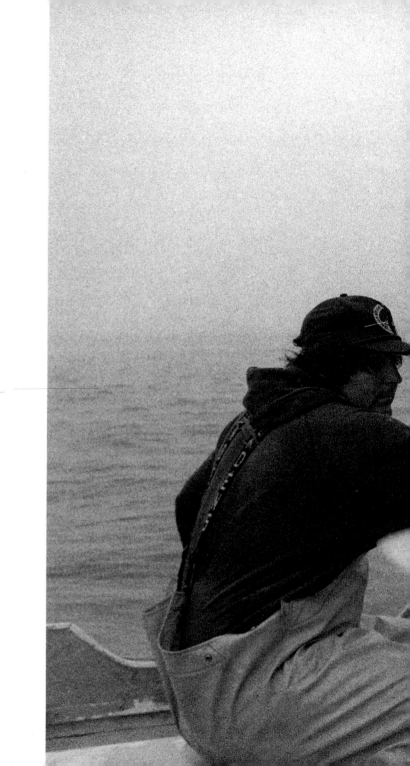

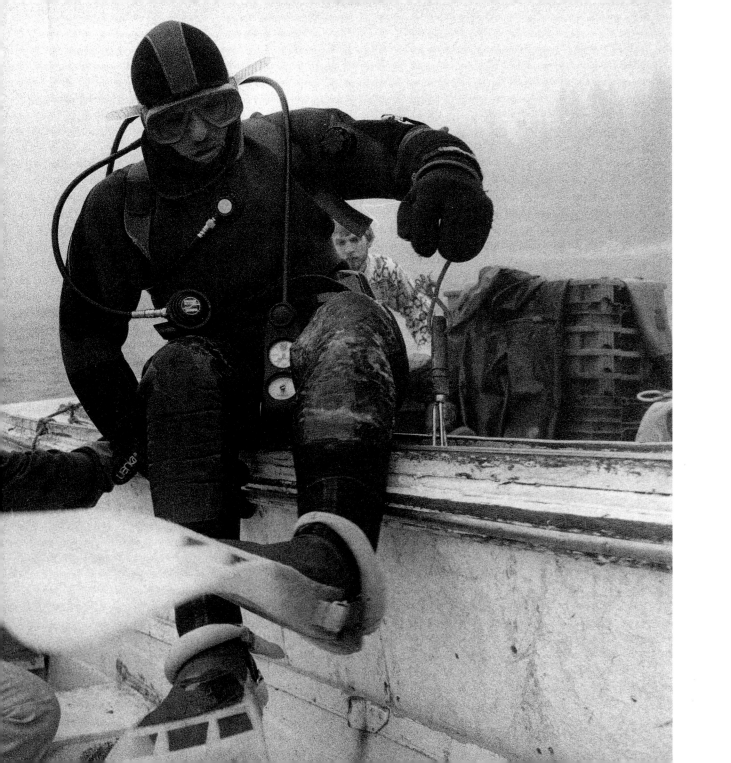

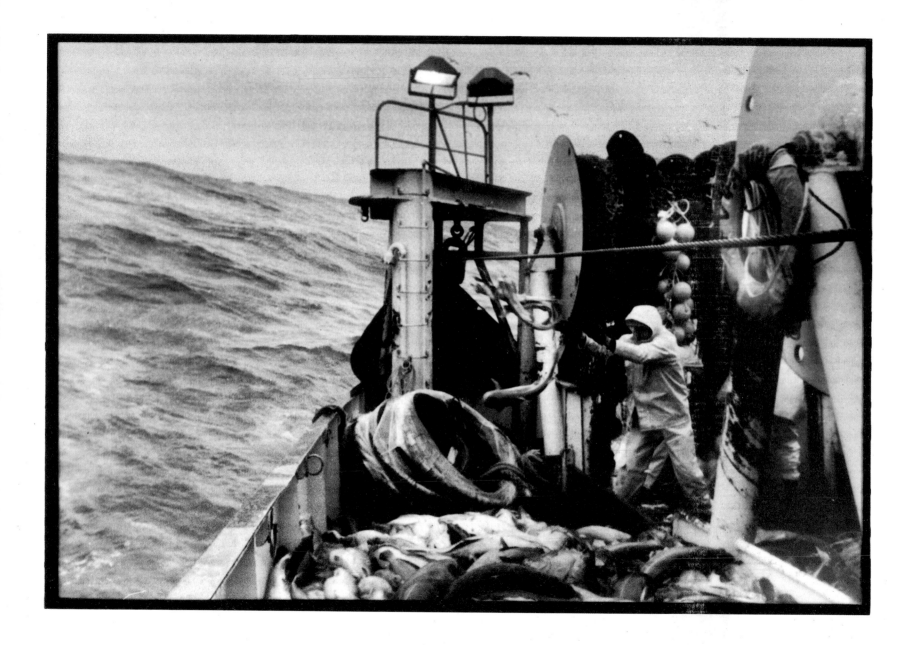

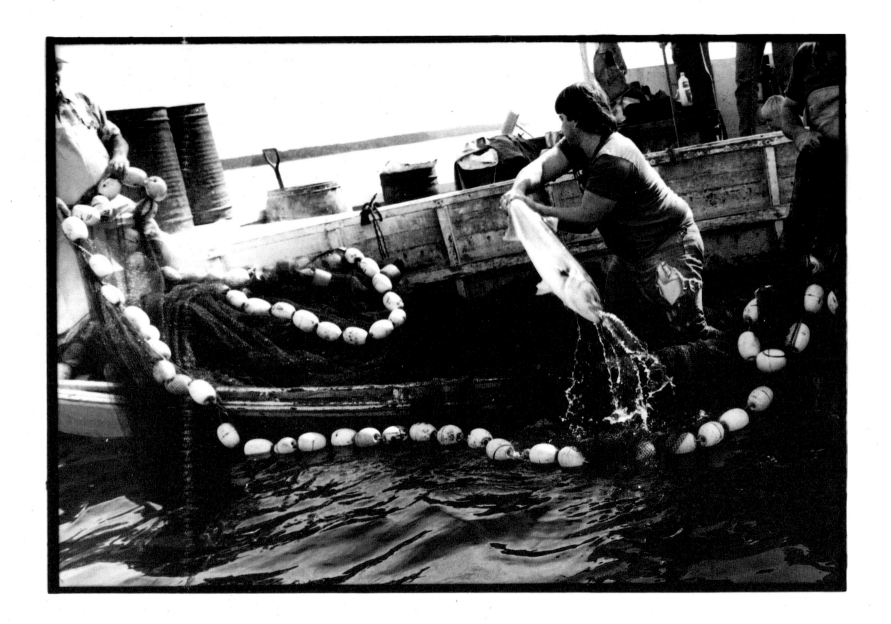

We are not a people of rude inquiry. We
let you bide your time, and then
in this time, your answers
fall like stars.

Brother, I see in your eyes,
the memory of tonight's rest.

List of Photographs

Acknowledgments

This book has been long in the making, and it wouldn't have happened at all without the help of a great number of people.

Major thanks to Lance Tapley for guiding me on the journey; to my daughter Anne Whitney Pierce for her true eye and her way with words; to Chris Crosman for his belief in my work.

My thanks to: Budget Copy (Berj, George, Anie); Bob Slate Stationer (Mallory Slate, Jimmy, Peter, Jodi); Kinko's Copies (Karl, Niels, Bill Wall, Lori); Huston-Tuttle (Greg, Cheryl, Derek, Marilyn), Good Impressions, Inc. (Louise); Cambridge Camera Exchange (Tony, Scott, Renée, Dick B.); A. Michelson & Co. (Richard and Sybil Michelson); John Salozzo and Paul Wilson, retouchers; Philip Levine, Inc. (Steve B. and Paul); Grimes Camera Repair (Steve G. and Charlie); S&H Construction, Inc.

Thanks to the following for exhibiting my work: Chocolate Church, Bath; Brown Bag Restaurant, Rockland (Anne Mahar); Calderwood Hall Gallery, North Haven (Herbert Parsons). For helping me with the text: Ann Collette, Richard D'Abate, David Godine, Jim Hatch, Carol Lewis, Margo MacLeod, Ron Phillips, David Rivera. For housing me in the cold winter months: Jeanne and Gerry Coopersmith, Helen Power, Judy and Christopher Harris. For piloting me around the bay: Travis Carter, Christine Monaco.

Thank you to the Bunting Institute of Radcliffe College (Florence Ladd, Gretchen Elmendorf); Round Top Center for the Arts (Nancy Freeman, Edmund Darrows); my Committee of Support: Gordon Bok, Paul Caponigro, Carolyn Chute, Chris Crosman, Madeleine Kunin, Seymour Slive, Benjamin Spock, M.D., Jean Weber.

My appreciation to those who generously funded the completion of the project: Deb Abrams, Michael Abramson, Maureen Ahern, Sally Amory, Ed and Nancy Andrews, Andrew Anisimov, Stanton Armour, Ron and Emily Axelrod, Kenneth and Roberta Axelson, Harriet Baxter, Marilyn Bibeau, Helen Black, Frances Bortz, Diane Bradsell, Sally Bradshaw, Howard Brooks, Patricia Buddenhagen, Kate Burnett, Gertrude and Carleton Burr, Eleanor Campbell, Cynara Cannatella, Dick and Ann Chamberlain, Ann Collette, Blanche E. Colman Trust, Gerry and Jeanne Coopersmith, Caitlin Corbett, Helen Davidoff-Hirsch, Pat and Jesse DeAngelis and Carol Lewis, Kevin Denny, Chris and Sarah Dewart, Clare Dewart, Mary and Murray Dewart, Paul and Eleanor Dietrich, Jim Doty, Chase Duffy, Susan Eaton, Robert and Sylvia Edwards, Clarissa Erving, Carol Evans and Jeff Halprin, Ken and Sandra Fabian, Jack and Joel Farber (Hunt Drug), Nancy Ferranti, Christopher Flower, Gaby Friedler, Betsy and Bob Gardner, Alex Gibney and Anne DeBevoise, Margot Gibney, Enid Gifford, Jane Goodwin, Peter and Sachiko Gordon, Ellen Green, Alice Hall, Bridget Hanson, Diana and Bob Harding, Francis Hatch, Ellen Higgins, Maddy Hildings, Granger Hill, Nancy Holmes, Lawrence and Tina

Howe, Augusta Howes, Albert Hunt, Sally Iselin, Virginie Isham, Dot and Sam Jennings, Trish Jennings and Jim Hatch, Arlene Johnson, Helen and Rudy Kass, Corning Kenly, Granger Kenly, Barbara and Irving Kreutz, Herman Lackner, Maria Lane, Arthur Lipkin and Bob Ellsworth, Sara Livermore, Henry and Carol Lukas, Sally and Edgar Lupfer, Barbara Marshall, Edward and Jean Mason, Jean McGuire and Barbara Herbert, Ann and Charles McLaughlin, Ari Miller, Edward Moore, Charles Myer, Judith Nadai, Helen and George Nagle, Mark Norton and Beth Ann Strollo, Tony and Lyn O'Sullivan, Jim and Eva Paddock, Emanuel Pariser, Katharine Park, Jean Parsons, Paul and Mary Perkins, Peggy and Jim Perkins, Kaethe Peters, Anne Pierce and Alex Slive, Bill and Lucille Pierce, George and Marjorie Pierce, Pat Pratt, Richard Pulsifer, Dorothy Reed, Jane Rich, Jane and Bob Richards, Marilyn Richardson and Charles Bering, Maurine Rothschild, Sheila Sadler, John and Mallory Semple, Jane Sherwin, Hilda Silverman, Katya Slive, Joel Sloman, Mary Minor Smith, Bonnie Solomon, Ellen Spaethling, Geraldine Spagnuolo, Eliot Spalding, John A. Stevenson, Carole and Gordon Talley, Isabel Thacher, Michael and Felicity Turner, Ethel Twichell, Sara Ulman, Lisa vonClemm, Anne F. Wallace, Laurence Wallace, Bill Whitaker, Jim and Linda White, Anna Yona.

For buoying me up, or saving me at critical moments: my son Laurence Pierce, my daughter Elizabeth Pierce, Maureen O'Sullivan, Alex Slive, Zoya and Seymour Slive, Linda White, Marie Clark, Pedy Rivera, Albert Monaco, Leon Brathwaite (framer), Megan Hanna (Hanna Design), Meris Bickford, Al Ferreira, Tappy Wilder, Bill Coffin, Peggy Tapley, Joanna Pool, Suzette McEvoy, Edith Murphy, Stephen Cole, Nathan Lipfert, Marilyn Hajer, Chris Killip, Shelby Lee Adams, Henry Horenstein, Glen Buckingham, Lee Campbell, Joyce Thompson (copy editor), Bill Thuss, Margot McWilliams, Susan Marsh (designer).

For permitting me to take pictures: Seacoast Engine & Pump (the *Fair Try*: Roger Woodman, owner; Will Viola, captain; Johnny Morrison; John McCarthy; Gordon Viola); Spruce Mountain Blueberries (Molly Sholes).

Posthumous thanks to Loyall Sewall for letting me photograph at Keene Narrows Lobster; to my friends Gordon Clark and Philip Bickford for their knowledge of the sea; to Charles Pratt for *Here On the Island*—an inspiration to me.

Above all, a warm thank-you to my friends on Gross Neck Road.

OLIVE PIERCE is a photographer, writer, and teacher. She is the author of *No Easy Roses: A Look at the Lives of City Teenagers.* For part of the year, she lives in Cambridge, Massachusetts, near her three children and six grandchildren. The rest of the time she spends in Maine.

David River photo

Olive Pierce photo

CAROLYN CHUTE is the author of *The Beans of Egypt, Maine, Letourneau's Used Auto Parts,* and *Merry Men.* She lives in western Maine with her husband Michael and six small dogs. She is working on a fourth novel.

These pictures were taken with Leica M3 and M4 cameras with 28mm and 21mm Elmarit lenses.

The book was typeset in Bembo by University Press of New England, and printed in duotone by Tien Wah Press.

UNIVERSITY PRESS OF NEW ENGLAND
publishes books under its own imprint and is the publisher for Brandeis University Press, Dartmouth College, Middlebury College Press, University of New Hampshire, University of Rhode Island, Tufts University, University of Vermont, Wesleyan University Press, and Salzburg Seminar.

Library of Congress Cataloging-in-Publication Data
Pierce, Olive.
 Up river : the story of a Maine fishing community / by Olive Pierce : with word pictures by Carolyn Chute.
 p. cm.— (Library of New England)
 ISBN 0–87451–756–7 (alk. paper)
 1. Atlantic Coast (Me.)—Social life and customs. 2. Fishing—Maine—Atlantic Coast. 3. Atlantic Coast (Me.)—Description and travel. I. Chute, Carolyn. II. Title. III. Series.
F27.A75P54 1996
974.1'009163'27—dc20 95-47137